WORLD FILM LOCATIONS
MUMBAI

Edited by Helio San Miguel

First Published in the UK in 2012 by Intellect Books, The Mill, Parnall Road, Fishponds, Bristol, BS16 3JG, UK

First Published in the USA in 2012 by Intellect Books, The University of Chicago Press, 1427 E. 60th Street, Chicago, IL 60637, USA

Copyright © 2012 Intellect Ltd

Cover photo: *Slumdog Millionaire* © 2008 Celador Films / Film4 / Pathé Pictures International

Copy Editor: Emma Rhys

A Catalogue record for this book is available from the British Library

World Film Locations Series
ISSN: 2045-9009
eISSN: 2045-9017

World Film Locations Mumbai
ISBN: 978-1-84150-632-6
eISBN: 978-1-84150-679-1

Printed and bound by Bell & Bain Limited, Glasgow

WORLD
FILM
LOCATIONS
MUMBAI

EDITOR
Helio San Miguel

ASSISTANT TO THE EDITOR
Devrath Sagar

SERIES EDITOR & DESIGN
Gabriel Solomons

CONTRIBUTORS
Alberto Elena
Lalitha Gopalan
Ranjani Mazumdar
Nandini Ramnath
Devrath Sagar
Helio San Miguel
Mayank Shekhar

LOCATION PHOTOGRAPHY
Ravi Bohra
Vikrant Chheda
Raj Hate
Devrath Sagar
Helio San Miguel
Sunhil Sippy

LOCATION MAPS
Joel Keightley

PUBLISHED BY
Intellect
The Mill, Parnall Road,
Fishponds, Bristol, BS16 3JG, UK
T: +44 (0) 117 9589910
F: +44 (0) 117 9589911
E: *info@intellectbooks.com*

Bookends: Mumbai street (Sunhil Sippy)
This page: Minara Mosque (Sunhil Sippy)
Overleaf: *Shree 420* (© 1955 R.K. Films Ltd.)

CONTENTS

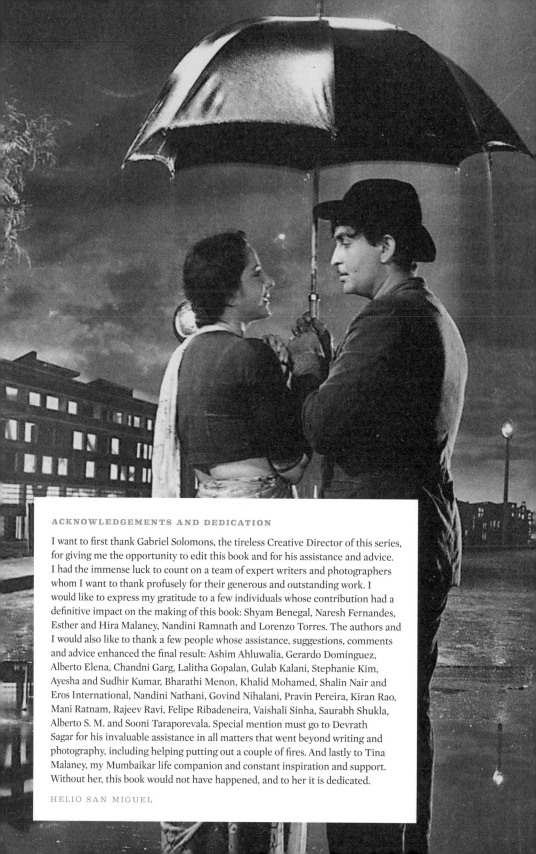

ACKNOWLEDGEMENTS AND DEDICATION

I want to first thank Gabriel Solomons, the tireless Creative Director of this series, for giving me the opportunity to edit this book and for his assistance and advice. I had the immense luck to count on a team of expert writers and photographers whom I want to thank profusely for their generous and outstanding work. I would like to express my gratitude to a few individuals whose contribution had a definitive impact on the making of this book: Shyam Benegal, Naresh Fernandes, Esther and Hira Malaney, Nandini Ramnath and Lorenzo Torres. The authors and I would also like to thank a few people whose assistance, suggestions, comments and advice enhanced the final result: Ashim Ahluwalia, Gerardo Domínguez, Alberto Elena, Chandni Garg, Lalitha Gopalan, Gulab Kalani, Stephanie Kim, Ayesha and Sudhir Kumar, Bharathi Menon, Khalid Mohamed, Shalin Nair and Eros International, Nandini Nathani, Govind Nihalani, Pravin Pereira, Kiran Rao, Mani Ratnam, Rajeev Ravi, Felipe Ribadeneira, Vaishali Sinha, Saurabh Shukla, Alberto S. M. and Sooni Taraporevala. Special mention must go to Devrath Sagar for his invaluable assistance in all matters that went beyond writing and photography, including helping putting out a couple of fires. And lastly to Tina Malaney, my Mumbaikar life companion and constant inspiration and support. Without her, this book would not have happened, and to her it is dedicated.

HELIO SAN MIGUEL

INTRODUCTION

World Film Locations Mumbai

WORLD FILM LOCATIONS: MUMBAI is an invitation to explore the manifold cinematic representations of this extreme metropolis, famously titled 'The City of Dreams'. Mumbai is India's financial capital, the main production centre of its film industry, the largest in the world, and its foremost film location. Until 1995 Mumbai was called Bombay. This name still powerfully reverberates, as many consider that the new name, due to its Hindu and Marathi leanings, harms the unique cosmopolitan character of a city built over the centuries by an amalgam of peoples and religions – Kolis, Gujaratis, Marwaris, Sindhis, South Indians, Portuguese, British, Hindus, Muslims, Parsis, Jews, Christians, etc. Independent institutions like the Bombay High Court and the Bombay Stock Exchange still keep the old name. We will call it Mumbai, but Bombay will appear in titles and references when the city still had its old name, or simply when an author wishes to keep it that way.

Originally an archipelago of seven small, scattered islands off the coast of Maharashtra, they morphed into Mumbai over centuries of land reclamation from the Arabian Sea. Still referred to as 'The Island City', and today officially named Mumbai City District, it is now a peninsula attached to the much larger Mumbai Suburban District that became part of the city in 1950. Today Mumbai encompasses these two districts that occupy Salsette Island almost in full, sharing it with part of the adjacent Thane District, and forming one of the most densely populated metropolitan areas in the world. Most of Mumbai's top attractions are in Mumbai City, especially in South Mumbai, but Mumbai Suburban District houses most film studios and Bandra, the wealthiest suburb and home to Bollywood stars and film-makers.

Through six insightful essays and 46 illustrated scene analyses by leading scholars and film critics, *World Film Locations: Mumbai* delves into the ways film-makers from India and abroad have represented Mumbai's kaleidoscopic nature. This city perfectly embodies the spirit and the collage format of this series that combines contextual essays with a rich visual component. The biggest challenge was precisely to determine the final selection of topics and films. Many deserving ones had to be left out –some painfully. Every Indian film buff familiar with this city can come up with a different and worthy list. Such is the wealth of the cinema about Mumbai. Thus, the disclosure made in other titles, that these books don't represent a comprehensive list of films shot in the city, also applies here. However, while the volumes on New York or Paris evoke films and places often known to readers, this book may likely serve more as a discovery for many unfamiliar with the cinema of Mumbai. With this in mind, *World Film Locations: Mumbai* offers an editorial selection in which having the locations as a guide, we have strived to find a balance between famous scenes, classic films, key directors and actors, film styles, significant themes and important periods, from Bollywood blockbusters to *parallel* cinema to foreign films.

I hope *World Film Locations: Mumbai*, and the films profiled and discussed in spotlights and scene analyses, can serve as a compass to journey into the often uncharted lands of this magnificent cinema and this arresting city, in whose hectic and relentless streets and studios the many faces of Indian cinema have crystallized and some of the most brilliant pages of its film history have been written. ✣

Helio San Miguel, Editor

MUMBAI

City of the Imagination

Text by
HELIO SAN
MIGUEL

MUMBAI, AN 'OVER-PAINTED COURTESAN' in the words of Satyajit Ray, 'at once seductive and revolting', is a fascinating, incommensurable and chaotic metropolis of astonishing social, religious and ethnic diversity, and heartbreaking extremes where immense wealth is just steps away from searing poverty. It's home to notorious mafias, violent communal riots, and is a target of international terrorism. But Mumbai is also the financial heart of India, possesses an industrious and growing middle class, hidden urban beauty, a rich intellectual life, a vibrant art scene, and as the home of Bollywood, it's India's film capital. If there's a city that can truly be called a city of the imagination, it is Mumbai. In fact, many cities, real and imaginary, inhabit Mumbai all at once. Cinema has both filmed them and created them, and they evoke multiple and contradictory images.

For western film-makers and spectators Mumbai frequently conjures up images that swing between the hopeless and the exotic. On one side, a representation of poverty, crime and alienation in the overpopulated megalopolis. Award-winning *Slumdog Millionaire* (Danny Boyle and Loveleen Tandan, 2008) dwells on this image, although infused by a Bollywood spirit, it incorporates a joyous ending. On the other side, films from *Son of India* (Jacques Feyder, 1931) to *Mission: Impossible – Ghost Protocol* (Brad Bird, 2011), that present Mumbai as a borderline orientalist fantasy, and are sometimes not even filmed there.

However, Mumbai is above all, Bollywood's quintessential metropolis. Bollywood, the focus of Alberto Elena's essay, is the Mumbai based mainstream Hindi film industry, oftentimes mistaken for the whole of India's commercial cinema at the cost of other regional film industries. Bollywood produces only about one fifth of the around 1,000 films made yearly in India, but they arouse the imagination of billions of people in Asia, Africa, Russia, the Indian diaspora, and increasing numbers of western spectators. Bollywood's Mumbai has been built both on its streets and in its numerous studios, from the legendary Bombay Talkies to contemporary Film City. Perhaps no other city has been so thoroughly filmed and recreated – and is so recognizable for its large and faithful audience. As Suketu Mehta remarks in *Maximum City: Bombay Lost and Found* (2004, p. 350), 'Through the movies, Indians have been living in Bombay all their lives, even those who have never actually been there.'

Cinematic Mumbai is the metaphor of an urban reality where all stories are possible and all dreams can be fulfilled. This Mumbai is a magnet for migrants from all over India lured by the excitement of the life they see in the movies. It's the modern and slick metropolis where upper-class Mumbaikars, who feel equally at home in London or New York, live in beautifully designed apartments. But it's also a city of temptation and peril that corrupts the honest villager searching for a better life. Mumbai symbolizes a mythical place of hope and disillusionment where the loftiest dreams sometimes clash with the harshest realities. CST station, Mumbai's iconic landmark, is frequently the threshold between the imaginary city and the real one, as millions of villagers, workers, gangsters and tourists, enter 'the city of dreams'. Mayank Shekhar composes an ode to Mumbai through this most important location, said to be India's second most photographed site after the majestic Taj Mahal.

But Mumbai can't be reduced to a few cinematic stereotypes, even if those represent the dominant discourse. Beyond them lies a more realistic representation, where the city becomes a character, the muse and the location. This Mumbai appears frequently in *middle* and *parallel* cinemas, as portrayed by

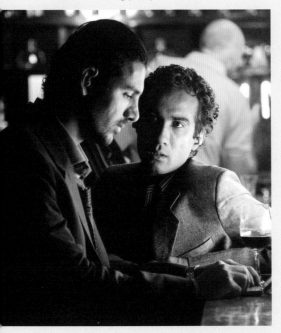

Above © 1988 Cadrage, Channel Four Films, Doordarshan

and traumatic events. Political corruption, infamous police encounters, gangsters, brutal class inequalities, housing problems, floods, prostitution, and even the budding topic of gay issues – from *Bomgay* (Riyad Vinci Wadia, 1996) to *I am* (Onir, 2010) – are all on display. As are the plight of millions of footpath and slum dwellers, and the Great Bombay Textile Strike, an event that dramatically altered the social fabric of the city. Even the most catastrophic events, the violent communal riots and ruthless terrorist attacks of the last two decades, receive prominent treatment, even in Bollywood films. Lalitha Gopalan's essay contextualizes the tragic December 1992 communal violence in a wider historical context and explores its pervasive presence in film and media. In addition, Mumbai's social issues are also represented in its rich documentary tradition –from Anand Patwardhan to Madhusree Dutta and Paromita Vohra – while its growing presence in a globalized economy is addressed in films like *John & Jane* (Ashim Ahluwalia, 2005), that deals with outsourced jobs, and *Made in India* (Rebecca Haimowitz and Vaishali Sinha, 2010) about Mumbai as a destination for inexpensive surrogate mothers.

Since Lumière's films were first shown in India at the Watson Hotel on 7 July 1896, Mumbai has always played a fundamental role in the development of Indian cinema. In Mumbai film life impregnates all aspects of city life. Colourful images advertising films can be seen everywhere, film songs become super hits, and 'filmi' is a common adjective. Even gangsters finance films, get extortion money from film-makers, and have actresses as mistresses. Mumbai is also the glamorous habitat of the Bollywood stars, whose status among their following dwarfs that of their western counterparts, and whose weight can be seen in the many dynasties that populate films and TV programs – the subject of Devrath Sagar's essay. Lastly, the city is home to two important festivals – 'Mumbai Film Festival' and 'Mumbai International Film Festival'.

When Salman Rushdie writes in *Midnight's Children* (2006, p. 30) that 'nobody from Bombay should be without a basic film vocabulary', he's simply expressing the profound and symbiotic relationship between the city, its cinema and its people. A relationship this book aspires to illuminate. ✣

such acclaimed directors as Shyam Benegal, Basu Chatterjee, Mani Kaul, Saeed Akhtar Mirza, Hrishikesh Mukherjee, etc. However, it also features prominently in films made within the coordinates of commercial Hindi cinema, but that don't comply with the telltale signs superficially identified with Bollywood. This is a Bollywood whose boundaries are being redrawn by cutting-edge film-makers – Ronni Screwvala, Ram Gopal Varma, Anurag Kashyap, Vishal Bhardwaj, etc. – who are redefining it, changing our perception of it, and leading it into a second golden era. Their films might astonish spectators who equate Bollywood with song-and-dance escapist fictions. Nandini Ramnath's illuminating essay guides us through these less travelled roads that she has aptly termed Counter-Bollywood, and Ranjani Mazumdar delves into the murky waters of Mumbai Noir, the successful genre that explores the city's underworld and its gritty urban tales.

This realistic Mumbai doesn't shy away from controversial topics

Since Lumière's films were first shown in India at the Watson Hotel on 7 July 1896, Mumbai has always played a fundamental role in the development of Indian cinema.

BOLLYWOOD

Text by
ALBERTO
ELENA

The Thousand Flavours of the Cinema of Mumbai

'IT'S A TERM ONLY foreigners who don't know our films use,' megastar Shah Rukh Khan told film critic and historian Derek Malcolm as late as 2002, referring to the already very common and widespread term 'Bollywood'. Today, however, nothing can be further from reality. It's true that the expression started being used in a tongue-in-cheek way in the 1970s as a word play between 'Bombay' (now Mumbai) and 'Hollywood', to refer to the commercial cinema in the Hindi language that emanates from the studios and production companies based in this city. But since then, 'Bollywood' not only has become a sort of brand name that is easily recognizable on a global scale, but also a real phenomenon that is earning increasing respect and even enjoying a growing academic legitimacy all over the world. Despite the original pejorative meaning, Bollywood emerges in the era of globalization as synonymous, according to Ravi Vasudevan, with a particular type of 'high-profile, export-oriented Bombay film' ('The Meaning of 'Bollywood" in jmionline.org), one that for the first time manages to combine production

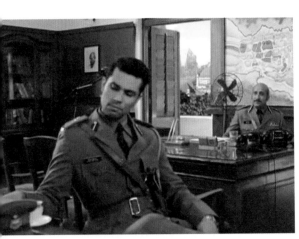

values that match those of any foreign film industry with a genuinely Indian spirit – and frequently also suffused with nationalist pride – and which at the same time succeeds in overcoming some of the customary hurdles that the distribution of popular Hindi cinema always faced abroad. Ashish Rajadhyaksha has also argued persuasively about the need to consider Bollywood as a phenomenon that transcends its own traditional boundaries to transform itself into a wider entertainment industry in which theatrical releases, DVDs, online streaming, cable and satellite TV, music rights, ringtones, merchandising and product placement, go hand in hand with amazing fluidity and exceptional commercial power.

Highly formulaic, Bollywood cinema has not renounced its well-known fondness for mixing genres according to the centenary aesthetic theory of the *rasa* (emotional themes) codified in the *Natya Shastra* by Indian theorist Bharata Muni around 2,000 years ago, nor the seasoning of the plots with songs and dances, already a common feature in various forms of traditional theatre, like Nautanki, and also in the influential nineteenth century Parsi Theatre. But at the same time Bollywood has succeeded in creating in the eyes of millions of spectators all around the world (although not precisely in most western countries yet) an identitarian badge and some sort of modernity alternative to Hollywood, that many proudly cheer on as a sign of resistance against cultural homogenization imposed from the outside. Spectators from the most remote corners of the world – many times belonging to the Non-Resident Indian diaspora, but not always – continue to get excited about what is offered by popular Hindi cinema, now conveniently updated regarding the nature of their stories, visual style and type of music that is used, whereas critics and scholars of international

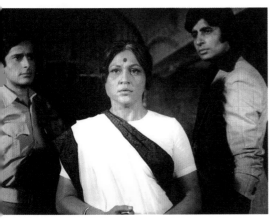

Above © 1975 Trimurti Films Pvt. Ltd.
Opposite © 2010 Balaji Motion Pictures

etymologies and iconographies, Mumbai constitutes the backbone of Bollywood as this city is, initially in close rivalry with Kolkata (then Calcutta), the great cradle of the Indian film production and its most robust fortress.

The struggle between these two cities lasted for a while, and in fact, India's first talkie, *Alam Ara* (Ardeshir Irani, 1931), was produced in Mumbai by Imperial Movietone and it opened less than a month before *Jamai Shashthi* (Amar Chaudhury, 1931) made by Madan Theatres, its Bengali competitor in Kolkata. In 1931, at the time of the arrival of sound, Mumbai was producing almost 65 per cent of all the films made in the subcontinent, and there were some occasional forays into Farsi and Burmese languages. From then on, the scale will tip more and more to the side of Mumbai. Since around World War II all the great studios of popular Hindi cinema, starting with the mythical Bombay Talkies and Prabhat Film Company, were located in the city and neighbouring areas (Kolhapur and Pune in the second of the abovementioned studios).

The fact that the local language of the state of Maharashtra, where Mumbai is the capital, is Marathi was not an obstacle for Mumbai to become the epicentre of film production in Hindi, and the supplier of what for a long time was called 'all-India films'. Hindus, Muslims and Parsis, not to mention other religions, as well as a fair amount of foreigners, would since the beginning come to provide, in harmonious and fruitful collaboration, the essential backbone for the film production of the great studios of the city. It would also be there where the great commercial formulas, like the so-called *masala* movies, would be created, developed, tested, and even exported to the other commercial regional cinemas of India, and also where from time to time the industry would house figures as singular and creative as Guru Dutt. And it would be there again where the extremely popular star system on a national scale would take root, from Nargis, Waheeda Rehman, Raj Kapoor, Dev Anand and Dilip Kumar, to Shah Rukh Khan, Aamir Khan, Salman Khan, Madhuri Dixit and Aishwarya Rai, through the always incommensurable Amitabh Bachchan.

The history of a significant part of Indian cinema, past and present, can be told from Mumbai. The history and the reality of the city has found in cinema one of its richest mirrors. ✣

repute find in those films an endless amount of imagination and vigour in constant and creative interrelationship with the influence received from Hollywood and other foreign cinemas. Of course things are not that simple, nor does the retrospective and anachronistic use of the term make it easy for a more nuanced analysis, but in any case, the brand 'Bollywood' is today seen as far from that Third World imitation of Hollywood that it was once considered.

And, of course, at the heart of Bollywood is the city of Mumbai. In the first place, because thousands and thousands of images of its films recall its powerful urban imagery, a specific iconography that so many films, from classics like *Taxi Driver* (Chetan Anand, 1954) to *Once Upon a Time in Mumbaai* (Milan Luthria, 2010), conjure up as a synonym for 'The City', whose name also appears in the titles of many more films. Also because of the close association between Mumbai and the extraordinarily popular – and socially influential – star system of Indian cinema, whose famous actors and actresses, along with film-makers and producers, mostly reside in the affluent suburb of Bandra in northwest Mumbai, and more specifically in the residential neighbourhood of Pali Hill. But above all, because beyond

> **Beyond etymologies and iconographies, Mumbai constitutes the backbone of Bollywood as this city is, initially in close rivalry with Kolkata (then Calcutta), the great cradle of the Indian film production and its most robust fortress.**

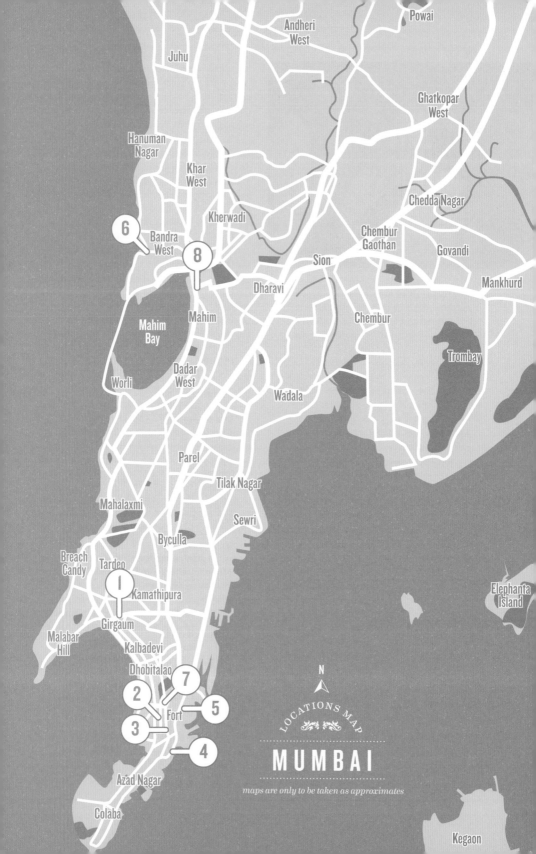

MUMBAI LOCATIONS

SCENES 1-8

AAG (1948)

Royal Opera House, Matthew Road, Opera House, Girgaum

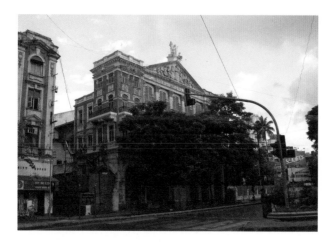

ALONG WITH GURU DUTT, Mehboob Khan, Bimal Roy, B. R. Chopra and the Anand brothers, Raj Kapoor dominated the Golden Era of Bombay Cinema in the 1950s. *Aag* (Fire) was his directorial debut, at the age of 23. It also signalled his encounter with Nargis, his muse over the coming years. They became one of the most enduring couples in Indian cinema, on and off screen, and their collaboration resulted in sixteen films. In *Aag*, Kewal, a driven youngster, chooses, after failing his college exams, to leave his studies and privileged family situation to chart his own destiny and pursue his dreams of doing theatre. In his quest he arrives in Bombay where he enters an abandoned opera house on whose stage he delivers a moving monologue. Unbeknownst to him the theatre owner is listening in the dark and touched by Kewal's passion decides to support his play. In the auditions for the leading female role they meet Nimmi (Nargis), a young woman who is a victim of the Partition. Just a few months after India has achieved its independence, their story spoke directly to the country's youth. The theatre where Kewal realizes his dreams is the Royal Opera House, the only surviving one in India. It was inaugurated by George V in 1911, later used in film premieres and concerts (famous playback singer Lata Mangeshkar debuted here) and finally closed down in 1993 after a fashion show. A slow restoration plan is underway to return it to its former glory.
➻ Helio San Miguel

(Photo © Vikrant Chheda)

Directed by Raj Kapoor
Scene description: Kewal delivers a passionate monologue in an empty and dilapidated theatre
Timecode for scene: 0:56:10 – 1:03:56

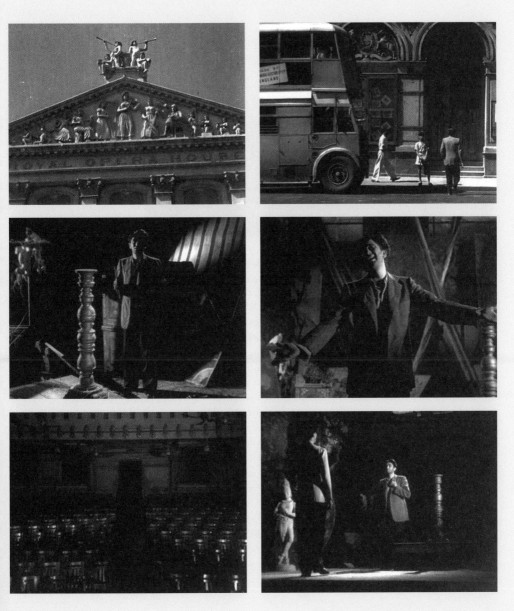

Images © 1948 R. K. Films Ltd

AWARA (1951)

LOCATION *Bombay High Court, 105 High Court (PWD) Building, Dr Kane Road, Kala Ghoda, Fort*

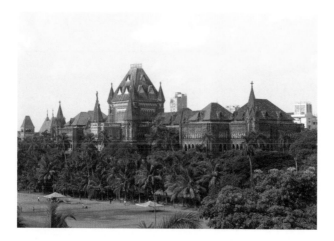

AWARA (VAGABOND) draws a parallel with Sita's abduction by Ravana in the *Ramayana*. Respected judge Raghunath throws Jagga in jail on a false conviction. His reasoning: Jagga's father was a criminal, so must he be. To seek revenge, upon his release Jagga kidnaps his wife, Leela. On realizing she's pregnant, Jagga releases her knowing the judge will throw her out for fear of public disgrace, much like Lord Rama had done with Sita. Alone and humiliated, Leela gives birth to their son Raj on a sidewalk. Even though he is the child of a well respected man, abject poverty and his bastard status forces Raj (Raj Kapoor) to follow the path of criminality under the tutelage of Jagga; thus proving that nurture plays as important a role in a person's development as nature. The film, penned by legendary leftist writer and film-maker Khwaja Ahmad Abbas, is woven around a trial where Raj's childhood sweetheart Rita (Nargis) defends him for attempting to kill judge Raghunath (played by Raj Kapoor's own father, Prithviraj). The trial takes place in the majestic Bombay High Court. Built by the British, this Gothic building is crowned with the statues of Justice and Mercy and has witnessed hearings since 1879. This brilliantly shot film was part of the official selection of the 1953 Cannes Film Festival. It became a massive success with critics and audiences alike, both in India and abroad, propelling Raj Kapoor and Nargis to international stardom. Its spectacular dream sequence and its famous song 'Awara Hoon' (I am a vagabond) still reverberate in people's minds. **→ Devrath Sagar**

(Photo © Devrath Sagar)

Directed by Raj Kapoor
Scene description: Trial at the Bombay High Court
Timecode for scene: 0:03:45 – 0:10:54

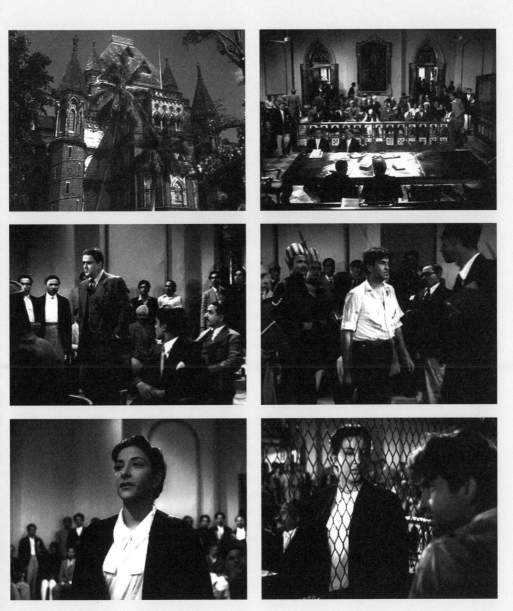

TAXI DRIVER (1954)

The Watson Hotel and Sassoon Library on Mahatma Gandhi Road, Kala Ghoda, Fort

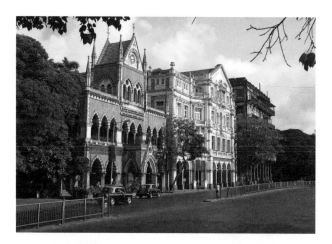

DUE TO BUDGET RESTRICTIONS Chetan Anand shot Taxi Driver mostly on location with a lighter camera. Bombay and its inhabitants are credited as characters. It became a huge success. Hero, played by Dev Anand, the director's brother and one of India's megastars, drives his Hillman Minx, Bombay's most famous taxi of choice until the 1970s, all over town, from Worli Sea Face to Marine Drive, showing us a city quieter and less congested than today. Hero frequently stops by a bar where Sylvie, a sensuous dancer (Sheila Ramani), goes after him. His interest however is on Mala (Kalpana Kartik, his real life wife), a naïve village girl who has come to Bombay to be a playback singer in films. He saves her from being attacked by goons and takes her to his house. When Hero's sister-in-law comes to visit, he makes Mala cut her hair and pretend to be a boy. Hero explains his situation to a friend as they drive down Mahatma Gandhi Road in Kala Ghoda (black horse), named after a statue of King Edward VII that stood there. Removed in 1965, it can still be seen as the taxi enters the street. We then see the historic Watson Hotel, where the Lumière films were first shown in India. Today, renamed Esplanade Mansion, this dilapidated landmark awaits restoration. As the taxi drives along, we see the Army building, the beautiful Sassoon Library and Elphinstone College. Kala Ghoda is Mumbai's art district and one of its most prominent areas. It houses some of its most important art galleries, museums and college campuses. ↬ **Helio San Miguel**

(Photo © Vikrant Chheda)

Directed by Chetan Anand
Scene description: Hero's taxi picks up a passenger on Mahatma Gandhi Road
Timecode for scene: 1:14:56 – 1:16:15

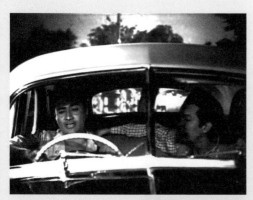
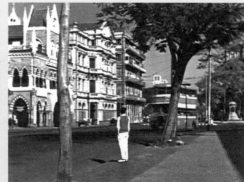
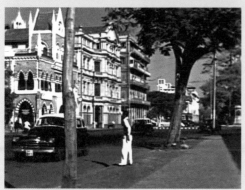
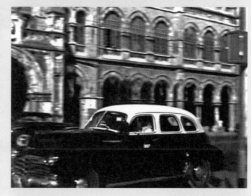
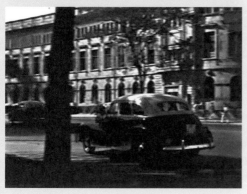

SHREE 420 (1955)

Taj Mahal Hotel Palace and Tower, P. J. Ramchandani Road, Colaba

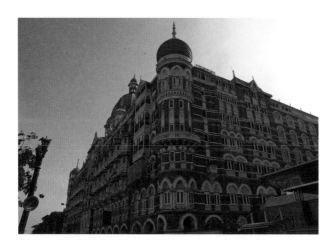

RAJ, A POOR BUT EDUCATED peasant inspired by Chaplin's tramp, arrives in Bombay determined to make an honest living rather than become a 'Mr 420' (the police code for thieves and crooks). His song 'Mera Joota Hai Japani' (my shoes are Japanese), where he declares that his heart is Hindustani, despite all else being foreign, remains to this day the most famous Indian film song. As in countless films he is divided between the virtuous woman Vidya (meaning wisdom, played by Nargis), and the vamp Maya (illusion, played by Nadira). When Maya realizes his natural talent for gambling, she takes him to the Taj, aptly named 'the temple of Laxmi', goddess of wealth, where Vidya feels out of place. Screenwriter K. A. Abbas, in this new collaboration with Kapoor, imbued Raj's journey from the footpath to opulence with denunciations of poverty and corruption. Located in Colaba, an important commercial and residential neighbourhood in South Mumbai, just steps away from the Gateway of India, the Taj is Mumbai's top hotel and one of the city's best-known landmarks. Built in 1903 by industrialist Jamsetji Tata, it's the playground of the rich and famous and a frequent film location. Tragically, it was also, along with CST, the main target of the November 2008 terrorist attacks. With security much heightened nowadays, it houses some of the best restaurants and stores, as well as a pleasant cafe by the pool, which feels like an oasis, albeit an expensive one, in the middle of the bustling city. **➻ Helio San Miguel**

(Photo © Vikrant Chheda)

Directed by Raj Kapoor
Scene description: Raj takes Vidya to the 'Temple of Laxmi' with disastrous consequences
Timecode for scene: 1:40:39 – 1:51:20

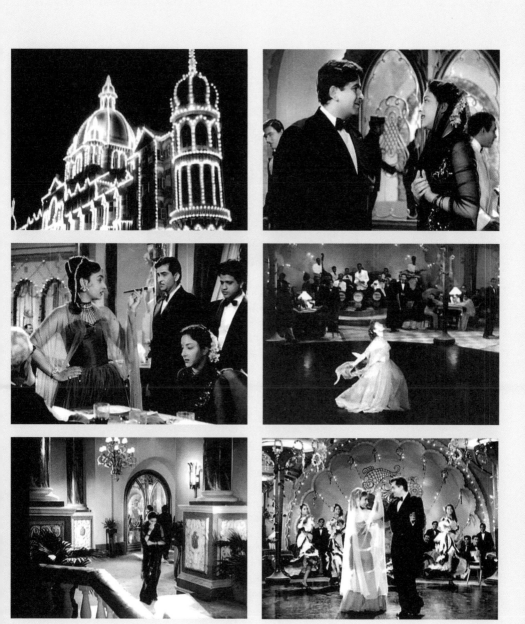

PYAASA (1957)

LOCATION *Town Hall – The Asiatic Society, Shahid Bhagat Singh Road at Horniman Circle, Fort*

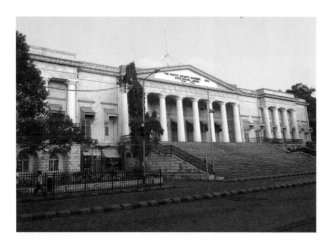

IN PYAASA (THIRSTY), Guru Dutt's cult classic, crowds struggle to enter a grand building where a commemorative event is taking place. It's Mumbai's Town Hall, finished in 1833 in neoclassical style and located just across Horniman Circle in one of the most regal areas of the city. Despite its name, it has not been used for local government offices, but as an important centre for social, political, academic and artistic events, and also houses the Asiatic Society. The event is in homage to Vijay (played by Guru Dutt himself), a destitute writer whose work nobody appreciated while alive. Posthumously published, his poetry became an overnight success. Now, even those who had previously rejected him rush to show off their close ties with the great deceased writer and profit from his fame. Vijay, however, was not dead. He unexpectedly shows up at the event where he delivers a diatribe against a callous and materialistic world in the form of perhaps the most arresting and lyrical song in Hindi cinema, 'Yeh Duniya Agar Mil Bhi Jaaye Toh Kya Hai' (Even if one wins this world, then what?). Shot by Dutt with virtuoso operatic camera movements that attest to his *mise-en-scène* mastery, this song was written by Sahir Ludhianvi, with music composed by S. D. Burman, and sung by Mohammed Rafi. In an unusual ending, a deeply disenchanted Vijay will leave with Gulabo (Waheeda Rehman), the proverbial prostitute with a heart of gold, a frequent archetype in Hindi cinema, who always believed in him and had paid for the publication of his poetry. **↝Helio San Miguel**

(Photo © Devrath Sagar)

Directed by Guru Dutt
Scene description: A poet whom everybody thought dead, appears at his own commemorative event
Timecode for scene: 1:58:20 – 2:06:35

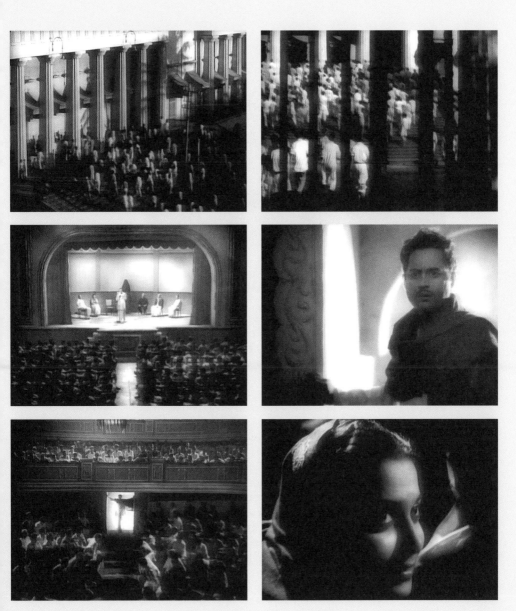

KAAGAZ KE PHOOL (1959)

LOCATION *Mehboob Studio, MT Carmel Road, Bandra West, Bandra*

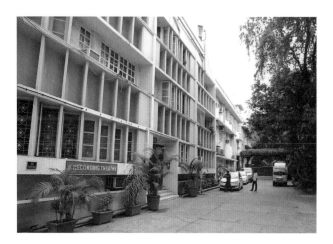

AS THE TITLES ROLL an elegant camera movement shows an old man (Guru Dutt) entering a film studio where he hides before the crew arrives. A flashback reveals he's Suresh Shina, a one-time star director, now forgotten. *Kaagaz Ke Phool* (Paper Flowers) is for many an autobiographical reflection, while for others an homage to Gyan Mukherjee, the director of *Kismet* (1943) who died three years earlier at the age of 47 and to whom *Pyaasa* (Thirsty; Guru Dutt, 1957) was dedicated. Dutt shot this film in the famous Mehboob Studio, located in Bandra. This studio was founded by celebrated film-maker Mehboob Khan in 1954, who chose the hammer and the sickle as its symbol. Many significant films have been made there, including Mehboob's legendary *Mother India* (1957). Still in operation, it is also used for concerts, and in 2011 housed Anish Kapoor's first art show in India. When the crew has left, Suresh Shina sits for one last time in the director's chair contemplating the empty soundstage and remembering his glorious past. In the morning they find him there. *Kaagaz Ke Phool*, the first Indian film made in cinemascope, failed at the box office. Guru Dutt, terribly disappointed, quit directing. Six years later, in a situation eerily similar to that of his character, he was found dead at the age of 39. Today considered a classic, *Kaagaz Ke Phool*, with its lyrical and melancholic tone, is a story of success and failure and a meditation on cinema and on the ephemeral nature of life and fame.
➔**Helio San Miguel**

(Photo © Devrath Sagar)

Directed by Guru Dutt
Scene description: A one-time successful director remembers his unfortunate life
Timecode for scene: 0:00:01 – 0:06:12 and 2:16:59 – 2:20:05

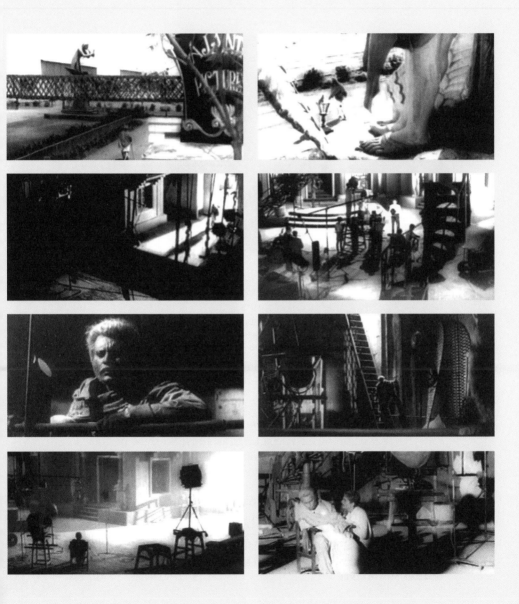

GUMRAH (1963)

Flora Fountain at Hutatma Chowk (Martyrs' Square),
Veer Nariman Road, Kala Ghoda, Fort

GUMRAH (ASTRAY) was produced and directed by B. R. Chopra, a major
figure of Bollywood's Golden Era and beyond, and Yash Chopra's older
brother. Chopra's films infused commercial Bollywood films with social
issues such as the effects of industrialization in the classic *Naya Daur*
(New Race, 1957); prostitution in *Sadhna* (Realize, 1958); death penalty in
Kanoon (Law, 1960), etc. He also produced (co-directed with his son Ravi)
the record-breaking TV series *Mahabharat* (1988–1990). *Gumrah* deals with
adultery, another daring topic for the period, and was a big success (it was
later remade in Malayalam). Sunil Dutt, husband of Nargis and father of
Sanjay, and Chopra's frequent star, plays Rajendra, a painter who is in love
with Meena (Mala Shina). They plan to get married, but her sister dies in
an accident leaving behind two small kids. Unwilling to oppose her father,
she accepts to marry widower Ashok (Ashok Kumar) and moves to Bombay.
Rajendra follows her and they start secretly seeing each other. Meena is then
blackmailed by a woman who says she's Rajendra's neglected wife. They
agree to meet at 4 p.m. at Flora Fountain, a very ornate sculpture dedicated
to the Roman goddess of flowers. Built in 1864, it's located in Hutatma
Chowk, the central square of South Mumbai, at the intersection of three of
the city's busiest avenues, Mahatma Gandhi, V. N. and D. N. roads. Deeply
torn between her marital obligations and her love, Meena also finds herself
at a desperate and untenable personal crossroads. **➺ Helio San Miguel**

(Photos © Raj Hate and Ravi Bohra)

Directed by B. R. Chopra
Scene description: Meena nervously waits for the woman who is blackmailing her
Timecode for scene: 2:09:08 – 2:12:15

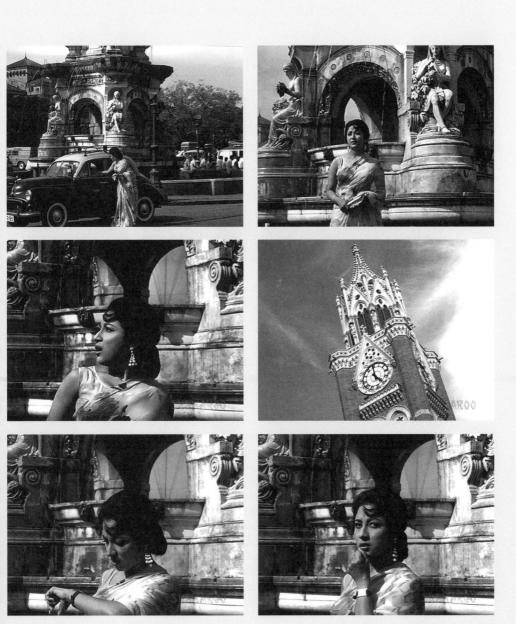

AAKHRI KHAT (1966)

LOCATION S.V. Road (Mahim Causeway)
between St Michael's Church and the Bandra Mosque

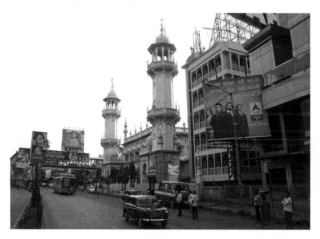

AAKHRI KHAT (THE LAST LETTER) is a most unusual Hindi film, directed by Chetan Anand for his own production company Himalaya Films. It's also Rajesh Khanna's debut film, although the second he shot (the first, *Raaz*, directed by Ravindra Dave, was released in 1967). Khanna will become India's top megastar until the emergence of Amitabh Bachchan in the mid 1970s. In *Aakhri Khat* he plays Govind, an artist who falls in love with Lajoo (Indrani Mukherjee), a village girl. They privately marry in a small temple, but when he returns to Bombay nobody believes her and she's forced to marry another man. She escapes and shows up pregnant at Govind's house, but he rejects her. Two years later and seriously ill, she leaves a letter in his mailbox informing him about the child and her plans to leave him at his door. She's finally unable to abandon the kid, but she dies soon after. Toddler Buntu (who gets well-deserved star treatment in the film titles) then roams around alone in the area between the Mahim Causeway and the Mahim Bay while Govind desperately looks for him. Anand counts among his achievements his first film, the pioneering social realist *Neecha Nagar* (Lowly City, 1946), a classic Indian film and co-winner of Cannes's top award. He also made the abovementioned *Taxi Driver* (1954), and the acclaimed *Haqeeqat* (Reality, 1964). However, *Aakhri Khat*, with its non-linear narrative, semi-documentary style, bold imagery and a jazzy experimental soundtrack, surpasses them all with its inventive cinematic form. **➵ Helio San Miguel**

(Photos © Vikrant Chheda)

Directed by Chetan Anand
Scene description: Lajoo leaves a letter in Govind's mailbox
Timecode for scene: 0:00:05 – 0:14:08

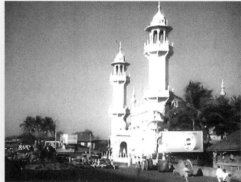
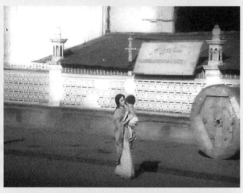
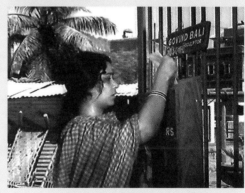

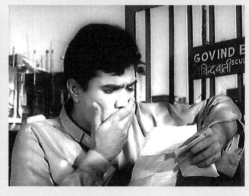

Images © 1966 Himalaya Films

VT (VICTORIA TERMINUS)

Gateway of India's Dreams

Text by MAYANK SHEKHAR

AFTER ADEQUATELY WARNING children against trying any such stunts, superhero G.One (Shah Rukh Khan) leapfrogs over and at right angles to a running train. The zingy background score reminds you of R. D. Burman, arguably India's most cutting edge composer who reigned over Bollywood in the 1970s; his remixes rule now. The running train, at top speed, its brakes not working, collides with the platform's railhead, juts out of the terminus and onto the main street that faces the city's municipal corporation headquarters. The light brown facade of the majestic station before us starts to slowly crack and then completely collapses, a statue of Queen Victoria falls alongside.

At this point, audiences in dark theatres are meant to round their lips, curl their tongue, whistle out aloud. This is an audience, separated by language, religion and ethnicity, yet united in their love for Bollywood stars. Finally, the heroine (Kareena Kapoor) in a striking red sari drops from the sky as the superhero holds her in his arms. The writers may have forgotten to weave this stunning sequence into a coherent plot for you to truly care. Yet, this remains the highlight scene of *RA.One* (Anubhav Sinha, 2011), India's most expensive film at the time of its release, made at around $30 million, about

thrice the budget of most Bollywood event pictures. This touch of Mumbai local was novel. Disaster films are produced in Hollywood, hence not set in India. The crumbling erection before us is the Chhatrapati Shivaji Terminus (CST), renamed in 1996 after a local warrior king. The structure has been known for most of its lifetime as the Victoria Terminus, or VT. *Endhiran/Robot* (S. Shankar, 2010), the other superhero blockbuster, this time starring Rajinikanth, southern India's top superstar, was also filmed here. This is not surprising.

VT is a declaration of the size of Mumbai's dreams. At the time of its construction in 1887, it validated Mumbai, or Bombay then, as the grand colonial outpost of the British Empire. Its inauguration marked the golden jubilee of Queen Victoria's accession to the British throne. This palatial monstrosity set in gothic architecture and listed as a Unesco World Heritage Site, greets you suddenly as you glide down a long, winding JJ flyover towards the part of the city they call 'town'. The structure, facing the main offices of Mumbai's municipal corporation and the *Times of India*, the world's largest English daily, looks over, from a distance, a bustling modern city, some of it reclaimed by the British from the mighty Arabian Sea.

That VT is also India's busiest railway station is not an afterthought. It strikes you the moment you're in its vicinity. Anonymous migrants, thousands of them, each an individual within this multiplicity, emerge from VT's various arch-shaped gates every minute, marching towards a city that has no patience to stand or stare. This is the opening sequence of Ram Gopal Varma's brilliant *Satya* (Truth, 1998). A top shot captures crowds coming out of a hole in VT. The camera zeroes in on one person, Satya (actor Chakravarthi), whose ambition, like that of others, seems to merge into a common sea of hope and despair. He's just arrived. Satya, the hero, is an immigrant who comes to Mumbai in search of a better life but ends up getting sucked into its notorious underworld

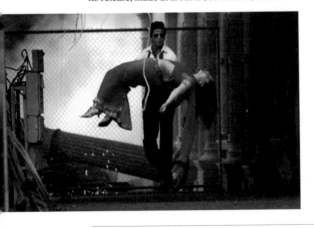

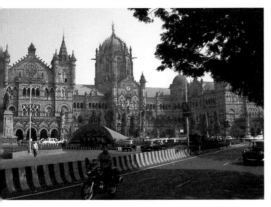

town over 7 million passengers in packed compartments every day. The buzz in the air as you walk into any of these stations is palpable. If you stand still at a spot on a platform when a train comes in, veterans say, the crowds could automatically carry you into the train! Sweaty Mumbaikars rub shoulders, jostling for space, almost elbowing their way towards their daily destinations, yet maintaining a strange sense of mechanical calm about it all. To the distant observer, these scenes, clichés in Mumbai films and literature, could seem like either an orgy of violence or love. Peace is usually a given. No one boils over.

Danny Boyle rightly shot the hard-core song-and-dance Oscar winning Bollywood song 'Jai Ho' (Be victorious) in *Slumdog Millionaire* (Danny Boyle and Loveleen Tandan, 2008) at VT. It was an unabashed tribute to the memento of love. One of the dancers featured in that video was a moving statue mimicking VT's British designer Frederick Stevens. Sadly that part of the song didn't make it to the final cut.

On 26 November 2008, just a few months after Boyle shot that song, in one of the deadliest terror attacks in recent history, Mumbai was held hostage by ten jihadi militants. The terrorists had captured, among other places, the city's landmark hotels Taj and Oberoi-Trident. Innocents were held captive, 168 people lost their lives, over 300 were injured. The city was left wounded.

As Salman Rushdie, arguably the greatest literary chronicler of Mumbai, puts it in his novel *The Moor's Last Sigh* (1996, p. 351), 'Those who hated India, those who sought to ruin it, would need to ruin Bombay.' I suppose they'd have to start with a shootout at VT. Nutcases on the night of 26 November did. Two young jihadists, armed with AK47s, entered the passenger hall of the crowded VT at around 9.30 p.m. that night, opening random fire, throwing grenades, killing 58 passengers, injuring over 100 others. Ajmal Kasab, one of the gangsters with the gun, was the only one caught during the coordinated attacks of 26/11.

Danny Boyle recalls in Amy Raphael's book, *Danny Boyle: In His Own Words* (2010), 'I went back (to VT) shortly after the terrorist murders, and it was already back to normal. It's like New York, London and Madrid. It doesn't matter what terrorists try to do. These cities will just carry on.' ✢

instead. The protagonist doesn't have a last name, we know nothing about where he's coming from, or where he's going. Somewhere between his dreams and reality lies Mumbai. Satya's story was also the story of Mumbai then. It rang true for its audiences in the 1990s, because it reflected accurately the city's fat underbelly that had been taken over by the mafia.

The influence of the underworld drastically declined in the post 9/11-world. A more dangerous tyranny of terrorism replaced it. Nothing seemed to dampen what they call the 'spirit of this city': a journalistic cliché, but absolutely true.

Poet Majrooh Sultanpuri wrote a song for the 1956 film *C.I.D.* (Raj Khosla) that became an anthem for Mumbai. In the film, the camera pans across VT. Comedian Johnny Walker, playing the mouth organ, walks past the station's grilled, columned walls, singing, 'Aye dil hai mushkil jeena yahan. Zara hatke. Zare bachke. Yeh hai Bambai meri jaan' (O gentle heart, it's not easy being here. Make way. Be careful. This is Bombay, my love).

Few monuments reflect the joyous energy of the cities they belong to as VT does. The station serves as terminus for both long-distance trains and two of the three main lines (Central and Harbour) of Mumbai's busy suburban rail system. Trains are the proverbial lifelines of Mumbai. They ferry to and from

Anonymous migrants, thousands of them, each an individual within this multiplicity, emerge from VT's various arch-shaped gates every minute, marching towards a city that has no patience to stand or stare.

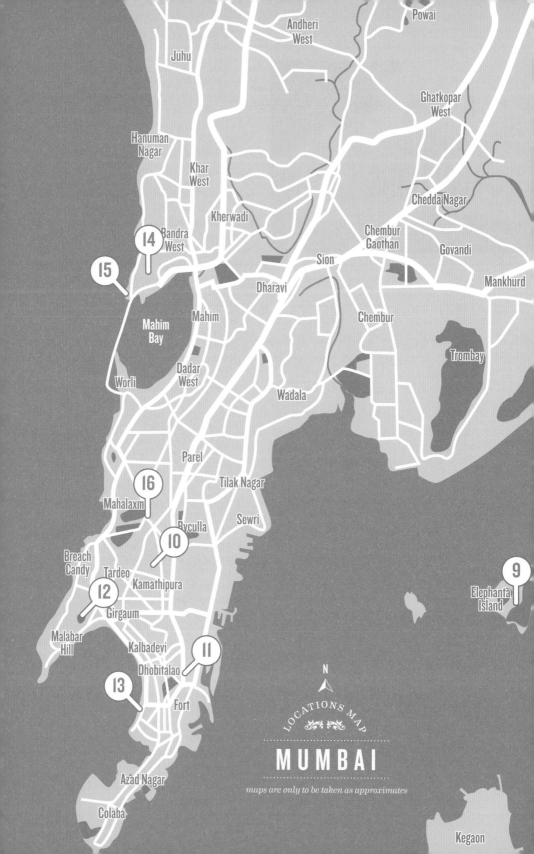

MUMBAI LOCATIONS

SCENES 9-16

BOMBAY TALKIE (1970)

Caves at Elephanta Island

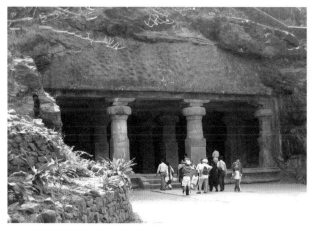

ISMAIL MERCHANT AND JAMES IVORY co-founded Merchant Ivory
Productions in 1961 with the intention of making English language films in
India for an international audience. Winning six Oscars along the way, this
prolific partnership produced films for over four decades. Known for their
stylized work, *Bombay Talkie*, set against the colourful Indian film industry
of the 1960s, was no exception. Opening on a surrealistic note, a successful
English author Lucia (Jennifer Kendal, Shashi Kapoor's actual wife) is given
a tour of a film set (the K. Asif Studios, named after its founder, the director
of the legendary *Mughal-e-Azam*, 1960) where dancers in carnivalesque
costumes prance around on the keys of a giant typewriter. She's introduced
to the film's cynical writer Hari (Zia Mohyeddin) and the handsome, married
star Vikram (Shashi Kapoor). Enamoured by her, Hari wants desperately
to be with Lucia but she goes after glamorous Vikram instead, destroying
his marriage. The tension comes to a boiling point when a quarrel erupts
between the two men at the Elephanta Caves. This set of seven caves
(five Hindu and two Buddhist), a Unesco World Heritage Site, is located
on Elephanta Island about 10 km east of Mumbai. Believed to have been
excavated between the fifth and eighth centuries AD, the main cave seen in
the film consists of a large hall supported by pillars with intricate sculptures
of Lord Shiva carved out of stone walls, each over 15 feet tall. In a story that
revolves around a home-wrecker, it is by no coincidence that the scene takes
place in a shrine to the Hindu god of destruction. **✤Devrath Sagar**

(Photos © Helio San Miguel)

Directed by James Ivory
Scene description: *Lucia, Vikram and Hari fight in Elephanta Caves*
Timecode for scene: *0:37:07 – 0:41:37*

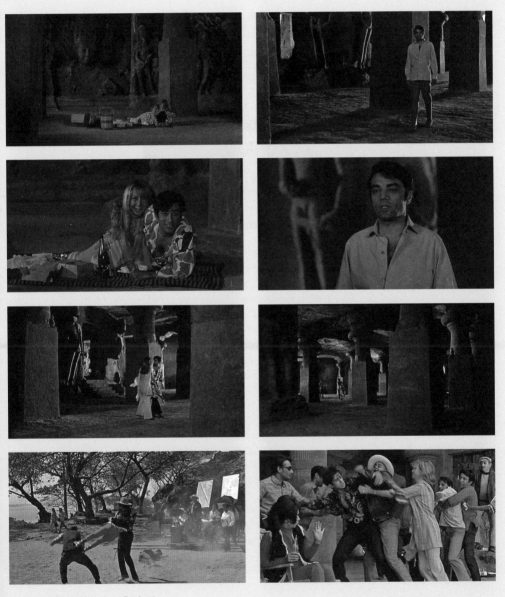

GUDDI (1971)

Film billboards all over the city

ARRIVING IN THE CITY of Mumbai has been a common trope in Indian cinema. Usually such an entry is established via Marine Drive or the Gateway of India, marking out iconic locations. In Hrishikesh Mukherjee's Guddi the entry into the city is uniquely staged as an encounter with a cinematic Mumbai. The film narrates the story of *Guddi*, a high school girl from a middle-class family obsessed with a film star, Dharmendra (who plays himself). This obsession threatens her ability to have a normal relationship of her own. During a trip to Mumbai with her sister-in-law, Guddi's first impression of the city unfolds via a series of painted billboards of the latest films. These billboards are displayed in a cluster near Juhu beach. Guddi sees the billboards in motion from her car. Mukherjee combines the camera moving over the billboards with a well-known song and a medley of dialogues from different films. The billboards come to life with the audio track and the most typical features of a popular Hindi film are generated – a combination of heroic lines, villainous dialogues, romantic moments, revenge themes and more. This is the cinematic city which houses the dreams and illusions produced by its film industry. Mukherjee attempts to unmask what he perceived to be the illusions of the popular form both for Guddi and for the spectator. Rather than present Mumbai as a tourist encounter, we see it in the film through its filmic world of billboards, studios and stars. ➻*Ranjani Mazumdar*

(Photo © Raj Hate)

Directed by Hrishikesh Mukherjee
Scene description: Guddi arrives in Bombay and can't take her eyes off the film billboards
Timecode for scene: 0:44:04 – 0:45:59

27 DOWN (1974)

IT IS NO EXAGGERATION to say that Sanjay's life is dominated by the railways. His father is an engine driver. He plays on the tracks as a child, and later jettisons his dreams of becoming an artist to join the railways as a ticket conductor. Sanjay prefers to sleep on the steel berths of a train rather than in the room he rents on the outskirts of Mumbai. In between his long-distance railway duty, he meets a woman on a local train. Shalini lives near an important local rail junction, Kurla. Their dates often take place at the railway canteen. When their relationship comes undone, Sanjay returns to the womb, as it were – he jumps onto the 27 Down and heads to Varanasi. The film could have just as appropriately been called Train Wreck. The film's director, Awtar Krishna Kaul, working with acclaimed cinematographer Apurba Kishore Bir, shoots entirely on location and captures unforgettable documentary-style images of local and long-distance train travel. The high-contrast, black-and-white camerawork pays rich dividends in a memorable top-angle sequence of a train pulling into an empty CST platform and disgorging its passengers. Mumbai's famous (some would say notorious) local trains have always carried more people than they should, even back then in 1974. It's safe to say that the director would have made more interesting films had he not died while trying to save somebody from drowning shortly before the film was released. Kaul left behind a film that questions the idea of the train as a sign of industrial progress. For Sanjay, the moving bogies constitute a journey into nowhereness. **↝Nandini Ramnath**

(Photo © Ravi Bohra)

Directed by Awtar Krishna Kaul
Scene description: Romance blossoms on a Mumbai local train
Timecode for scene: 0:27:58 – 0:31:22

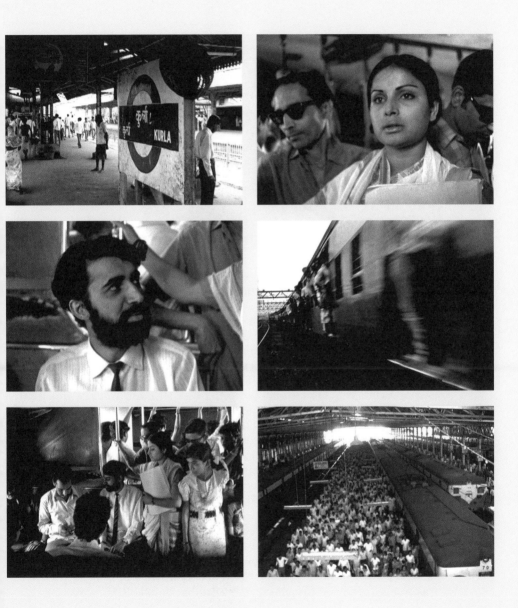

RAJNIGANDHA (1972)

Hanging Gardens, Kamala Nehru Park, B. G. Kher Road, Malabar Hill

BASU CHATTERJEE, along with Hrishikesh Mukherjee, offered a distinctive voice within Indian cinema. Far from the excess of commercial Bollywood films and from *parallel cinema* concerns with poverty and injustice, they concentrated on showing the real life predicaments of the middle class. Their style was thus termed *middle-class cinema*. In *Rajnigandha* (tuberose, a night-blooming plant), Deepa (Vidya Sinha) lives in Delhi, where she is engaged to Sanjay (Amol Palekar), a social activist, who at the same time is somewhat lazy and thoughtless. When Deepa gets a job offer in Bombay, she reacquaints with her previous boyfriend Navin (Dinesh Thakur). He's the opposite of Sanjay, attentive, punctual and always helpful. Trying to rekindle their relationship, Navin takes her to parties in and around the city. Chatterjee reinforces Deepa's confusion with unconventional touches – voice-over thoughts, freeze frames, jumps between reality and imagination. One day Navin takes her to the Hanging Gardens, built in the 1880s in upscale Malabar Hill, close to the Tower of Silence. In 1899 *The Wrestlers*, considered the first Indian film and today lost, was shot there by film pioneer Harishchandra Sakharam Bhatavdekar (known as Save Dada). The whimsical nature of the Hanging Gardens with a shoe-shaped house and hedges and trees pruned in the forms of animals, reflects Deepa's emotional state in Bombay. However, in the end she will reject the job offer and go back to Sanjay and the stability of Delhi. ➤*Helio San Miguel*

(Photo © Raj Hate)

Directed by Basu Chatterjee
Scene description: *Navin takes Deepa to the Hanging Gardens*
Timecode for scene: *1:07:34 – 1:09:53*

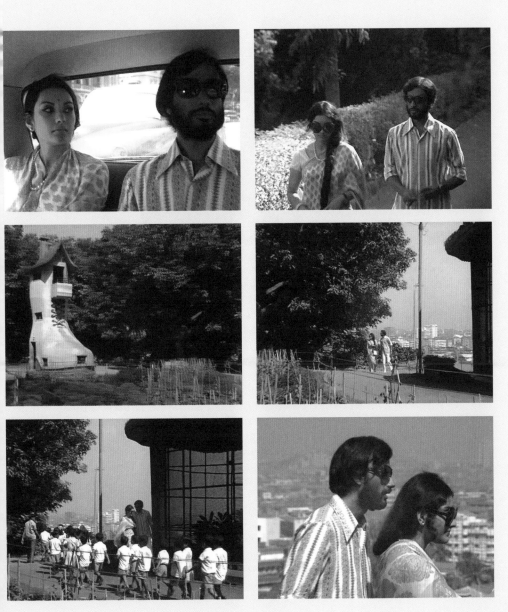

DEEWAAR (1975)

Marine Drive, as seen from the Oberoi Trident Hotel in Nariman Point

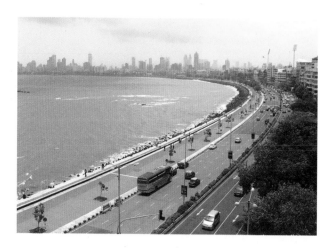

IN THE CLASSIC FILM *Deewaar* (The Wall) an honest union leader is forced to betray his co-workers to save his family. Ashamed he abandons the village, but his wife and kids suffer constant abuse. When one child has the line 'my father is a thief' tattooed on his arm, the mother realizes they must leave. Their destination is on the wall: a calendar with a black-and-white picture of Marine Drive, South Mumbai's imposing promenade that forms a curve from Nariman Point to Malabar Hill. Also known as the Queen's Necklace it has an impressive collection of art deco buildings. The mother will work at construction sites to exhaustion, while the kids, brought up under a bridge, will grow up in diverging paths. The brother with the tattoo becomes a smuggler, while the other a policeman. A meeting under the same bridge where they grew up makes it clear that their worlds are separated by an invisible but insurmountable wall. The smuggler is played by Amitabh Bachchan, India's biggest megastar ever, who embodies the revengeful 'angry young man' he initiated in the preceding film *Zanjeer* (Prakash Mehra, 1973), and who will dominate two decades of Bollywood cinema. With dated 1970s clothes and music, he makes it big in Bombay and figuratively and literally rises to the top criminal echelons. He can now contemplate Marine Drive from high up, but he will not be able to erase the image of a poor woman walking with her two kids down below.
⁂Helio San Miguel

(Photo © Vikrant Chheda)

Directed by Yash Chopra
Scene description: A mother and her two small kids arrive in Bombay to start a new life
Timecode for scene: 0:20:32 – 0:21:45

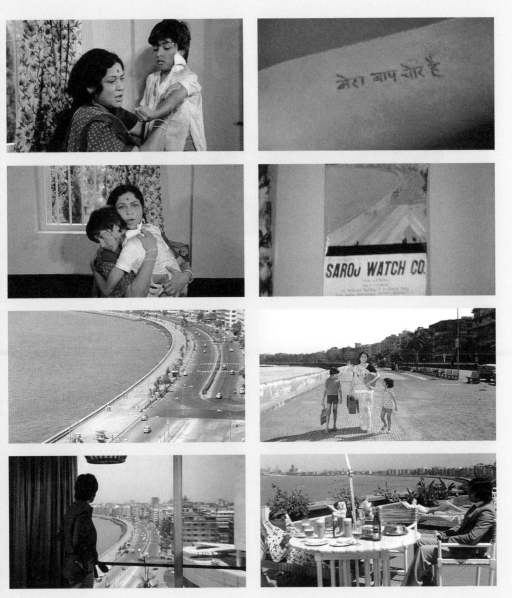

AMAR AKBAR ANTHONY (1977)

LOCATION *Basilica of Our Lady of the Mount, Mount Mary Road, Bandra West, Bandra*

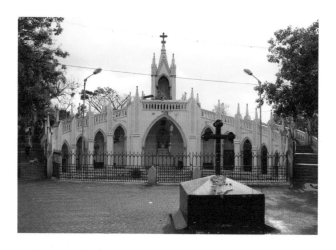

BLOCKBUSTER *AMAR AKBAR ANTHONY*, directed by Manmohan Desai, epitomizes the *masala* movie, a popular type of Hindi film that for many spectators is synonymous with Bollywood. *Masala*, the mix of spices in Indian cuisine, refers here to a recipe made with a combination of genres (melodrama, comedy, action, romance, etc.), song-and-dance numbers, multiple and fairly convoluted plots, and improbable coincidences. Desai himself is credited with its invention. Its impact can be felt in other Indian cinemas as well as in western titles like *Moulin Rouge!* (Baz Luhrmann, 2001) and *Slumdog Millionaire* (Danny Boyle and Loveleen Tandan, 2008). In *Amar Akbar Anthony*, three small brothers are separated when their father is framed and their mother becomes blind. They're brought up as Hindu, Muslim and Christian. Through many adventures they repair injustices, discover the truth, reunite, and each find a girlfriend from their own religion. Anthony, who was adopted by a priest, survives on shady dealings, but still helps in the church where he was found. One day he sees beautiful Jenny (Parveen Babi) at the mass and falls in love with her. The church is the Basilica of Our Lady of the Mount, better known as Mount Mary, located in Bandra. The popular Bandra Fair takes place there every September to commemorate the Virgin Mary's birthday. The current church was inaugurated in 1904, but its origins date back to a sixteenth century chapel erected by Portuguese Jesuits and rebuilt several times since. An oratory to Our Lady of Fatima, which we see in the background of Jenny's close-up, was added in 1954. ↦ *Helio San Miguel*

(Photo © Devrath Sagar)

Directed by Manmohan Desai
Scene description: *Love at first sight when Anthony sees Jenny at a church*
Timecode for scene: *1:14:16 – 1:18:29*

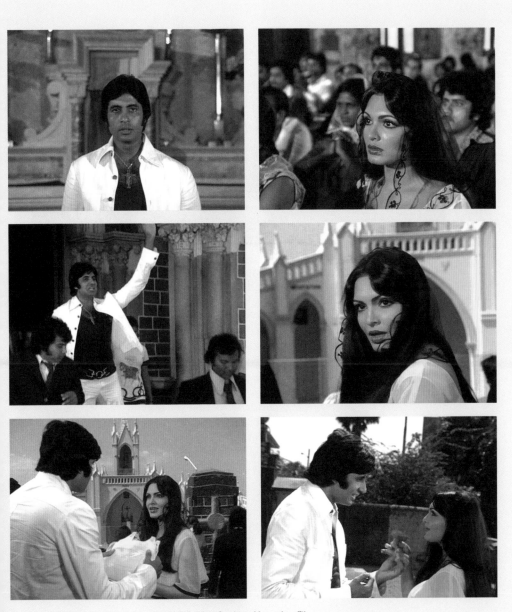

GHARAONDA (1977)

LOCATION *Bandra Fort, Bandra West, Bandra*

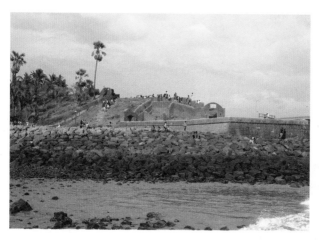

SUDIP AND CHHAYA share an office and a dream: to get married and own an apartment. That's easier said than done in Mumbai, where real estate sometimes costs as much as a trip to the moon. The couple settles on an affordable option, but the builder cheats them out of their money. In its middle-class setting and use of real locations and *vérité* camerawork, *Gharaonda* (The Nest) is a typical example of cinema from the 1970s. Reputed cinematographer A. K. Bir frames the characters against the city itself. Sudip and Chhaya take the bus, wander through the streets, and bicker in cafes. In the song 'Do Deewane Shaher Mein' (Two crazy lovers in the city), they lip-sync their optimism at the construction site of their apartment block and later frolic at Bandra Fort, built by the Portuguese in the seventeenth century and overlooking the Arabian Sea. In an earlier song, 'Tumhe Ho Na Ho' (You have it or you don't), they cuddle together at Marine Drive and Naaz Café in Malabar Hill, which, before it shut down, was a popular shooting location because it offered a panoramic view of Mumbai. The city is less crowded and more beautiful than it is at present, but don't be fooled by appearances. Chhaya sells her soul to find happiness, leaving Sudip with a broken heart and a shattered dream. Although Mumbai has one of the highest property rates in the world, few films have dealt with the issue. This film offers a possible explanation to the mystery. •➤*Nandini Ramnath*

(Photos © Devrath Sagar)

Directed by Bhimsain Khurana
Scene description: Sudip and Chhaya walk around Bandra Fort
Timecode for scene: 0:49:47 – 0:54:07

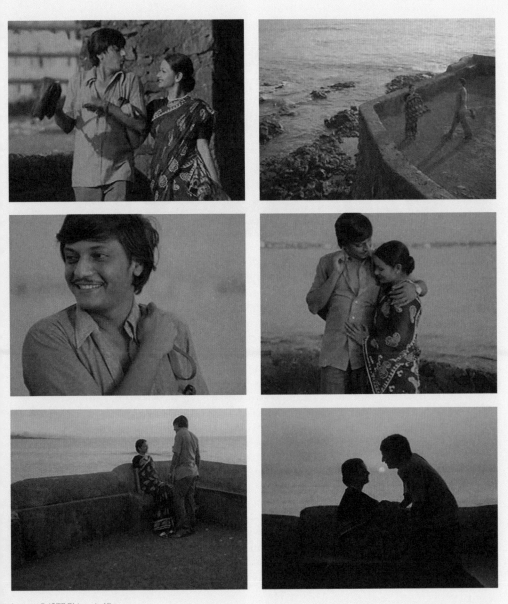

DON (1978)

Dhobi Ghat, Mahalaxmi

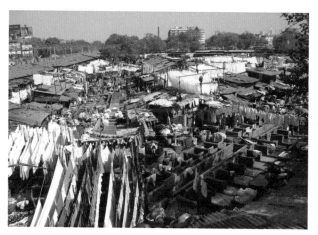

AMITABH BACHCHAN ruled the 1970s like no other Hindi cinema actor. He appeared in roles that covered a range of emotional states – happy, sad, angry, pensive. *Don*, in which he plays a double role, sees the star at his insouciant best. *Don* has Helen shimmying in a shimmery outfit and glam doll Zeenat Aman wearing the shortest nurse's uniform in the history of Indian medicine, but that is nothing compared to the sight of Bachchan emerging Ursula Andress-like out of a swimming pool. He also looks rather fetching while dancing in a lungi outside the iconic Taj Mahal Hotel at the historic Gateway of India. *Don*'s director is Chandra Barot, but it is fair to say that the producer, Nariman Irani, is more significant for the purposes of this review. Irani, a debt-ridden cinematographer who produced *Don* to make some fast cash, put his skills to good effect in two key chase sequences. The first, which sets the tone for the film, sees the ruthless gangster Don shake off a bunch of rivals by driving down the wrong side of several arterial Mumbai streets, including in the business district of Fort. By the time the next chase sequence arrives, Don has died and been replaced, *Kagemusha*-like, with his spitting image by a police officer. The fake Don too must run for his life, finally crashing into several white sheets of drying linen at Dhobi Ghat in Mahalaxmi. The open-air washing area in south-central Mumbai has enchanted tourists for years, and provided the title and a major sub-plot for Kiran Rao's debut feature. **⇢*Nandini Ramnath***

(Photos © Helio San Miguel and Ravi Bohra)

Directed by Chandra Barot
Scene description: Don's duplicate runs for his life
Timecode for scene: 1:55:23 – 1:56:55

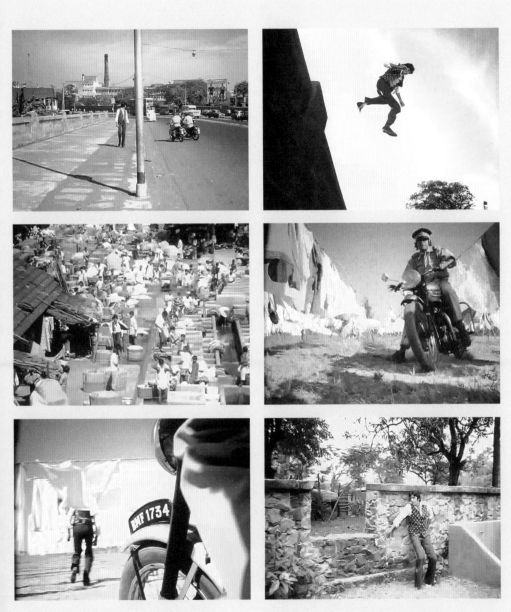

COUNTER-BOLLYWOOD

Realist Fables from the City of Dreams

Text by
NANDINI
RAMNATH

MUMBAI IS ONE OF the biggest cities in the world, but thanks to the movies, it can be conjured up on the screen by only a handful of locations – CST, the Gateway of India, the Marine Drive promenade in the south, Juhu beach up north, the modern high-rises and the Dickensian cloth-and-tin shanties. But of late, the city has been missing from mainstream cinema. Most big-budget Bollywood productions – the ones with beautiful stars, song-and-dance interludes, pretty sets and the rest of the bells and whistles – prefer to retreat to studios or migrate to cities in the United States, Great Britain, Australia or even Spain.

The reasons are not too far to seek – sometimes, they lie just beyond the drawing room window. Mumbai evokes all kinds of adjectives, one of which is 'brutal'. The city is sagging under the weight of almost 20 million people, 60 per cent of whom live in slums because of prohibitive real estate rates and a severe lack of low-cost housing. These days, vast parts of the megalopolis resemble construction sites, since at any given point there is always a flyover being built, a new housing project being erected or, if not anything else, water pipes being repaired. Digging has become a citywide pastime of late, so if many film-makers shy away from setting their cameras on street corners, they deserve some sympathy. Brave are the producers who decide to shoot outdoors: they will need to tackle a mind-numbing list of official permissions (as well as unofficial bribes that need to be handed out to fixers and government lackeys) and unruly crowds that assemble no sooner than a vanity van has pulled up. But bravery is a quality that isn't lacking among independent-minded film-makers who deal with social realities. Mumbai as a location survives in the cinema that swims on the edges of the mainstream – let's call it Counter-Bollywood. Verisimilitude and realism are one of the distinguishing characteristics of a cinema that has been variously referred to as *middle*, *parallel* or *offbeat*. Films that deal with gritty, dark and potentially unsalable subjects like poverty and unemployment move away from Bollywood's dreaminess and rely on realistic portrayals of ordinary people and the worlds they inhabit.

In the 1970s and 1980s, the best way to prove realist credentials was to move out of the city and into the village. The early films of directors like Shyam Benegal (*Ankur/The Seedling* [1974], *Nishaant/Night's End* [1975], *Manthan* [1976]), Govind Nihalani (*Aakrosh* [1980]) and Ketan Mehta (*Bhavni Bhavai* [1980], *Mirch Masala* [1987]) examined the problems faced by rural India. When *parallel* film-makers returned to Mumbai, they rejected Marine Drive and Juhu Beach and repaired to the city's working-class neighbourhoods. The exploration of blue-collar Mumbai in Saeed Akhtar Mirza's *Albert Pinto Ko Gussa Kyon Ata Hai* (What Makes Albert Pinto Angry, 1980), about the angst-bitten son of a mill worker, is more poignant than Mirza or his talented cinematographer Virendra Saini could have imagined. The mill district of central Mumbai has been transformed beyond recognition by the infusion of global capital into the city since the mid-1990s, with chimneys and single-room tenements replaced by malls and high-rises. Mirza also put the city's Muslim-majority Dongri neighbourhood into focus with *Salim Langde Pe Mat Rao* (Don't Cry for Salim the Lame, 1989), making memorable use of its humble eating joints, teeming streets and hovels.

Counter-Bollywood cinema has always reaped the benefits of casting relatively lesser-known faces. Directors got their actors to walk down the city's streets seemingly unnoticed, use public transport, and conduct romances in parks and restaurants. In Basu Chatterjee's *Chhoti Si Baat* (Such a Small Thing, 1975), lead pair Amol

Palekar and Vidya Sinha ride a double-decker bus and walk through the business district in Nariman Point. Palekar was back on the streets for the director's *Baton Baton Mein* (1979) – this time, he romanced Tina Munim by the sea and in crowded commuter trains. Anurag Kashyap's *Black Friday* (2004) inventively set a chase scene in the Dharavi slum, while Kiran Rao's *Dhobi Ghat/Mumbai Diaries* (2010) used iconic city locations such as the open-air washermen's colony in Mahalaxmi and densely packed Bhendi Bazaar.

The diverse ways in which Mumbai residents live – boxy apartments, colonial-era villas, neatly planned residential colonies – have also allowed realist film-makers to explore different sets of urban experiences. Basu Bhattacharya's *Anubhav* (1971), about the marital discord between a westernised advertising professional and his wife, is set in an apartment (which belonged to the film's lead actor Tanuja) in the city's affluent Altamount Road neighbourhood. The decor as well as Tanuja's saris reflect the vogue for hand-woven fabrics among the city's wealthy at the time. Sai Paranjape's comedy *Katha* (1983), a satire about middle-class morality, is set in a typical Mumbai chawl, a housing arrangement comprising single rooms with common-use toilets. Govind Nihalani's *Party* (1984), a bracing attack on the city's chattering classes, derives its narrative power from

> The diverse ways in which Mumbai residents live – boxy apartments, colonial-era villas, neatly planned residential colonies – have allowed realist film-makers to explore different sets of urban experiences.

the well-appointed apartment in which it is set. Domestic spaces that speak volumes about the city's class differences are present in Kundan Shah's *Jaane Bhi Do Yaaro* (1983), Anurag Kashyap's *No Smoking* (2007) and Kiran Rao's *Dhobi Ghat/Mumbai Diaries* (2010). Sooni Taraporevala's *Little Zizou* (2008) uses the self-enclosed and occasionally claustrophobic self-world of the Parsi baug – a residential enclave housing members of the Zoroastrian faith – as a metaphor for both belonging and disorientation.

The most potent visual signifier of Mumbai's socio-economic divide remains the slum. Many years before Danny Boyle's English production *Slumdog Millionaire*, (Danny Boyle and Loveleen Tandan, 2008), local film-makers rooted stories of hope and despair in Dharavi and beyond. Before Sudhir Mishra's *Dharavi* (1992), which looked at a taxi driver's desperate attempts to negotiate his way out of poverty, there was Rabindra Dharmaraj's *Chakra* (1981), for which Satyajit Ray's long-time production designer Bansi Chandragupta created an extremely convincing slum set. Dharmaraj juxtaposed scenes shot on the set with footage of the film's lead actor, Smita Patil, walking unrecognized through Dharavi. Recent films have less convincingly used slums to explore the lives of Mumbai's underclass, such as Madhur Bhandarkar's *Traffic Signal* (2007), Raja Manon's *Barah Aana* (2009) and Faruk Kabir's *Allah Ke Banday* (2010).

In a fast-mutating urban landscape, the slum has emerged as a link with the past. Contemporary Mumbai is a far less interesting place than it used to be, with diversity being replaced by sameness. The trend of verticality in recent construction – vividly expressed by high-priced cookie-cutter skyscrapers and glass-fronted office buildings – is threatening the mix of low-rises, cottages, villas and chawls that gave the city its distinctive look. Mumbai isn't the only source of inspiration for Counter-Bollywood film-makers any more: many of them are looking at other cities for inspiration. Delhi is a new hunting ground for such directors as Dibakar Banerjee (*Oye Lucky! Lucky Oye!* [2008]) and Maneesh Sharma (*Band Baaja Baaraat/Wedding Planners* [2010]). The street has been snatched away; the skyscraper is now mostly inaccessible. The slum is now the most effective representative of the city's dreams and nightmares. ✢

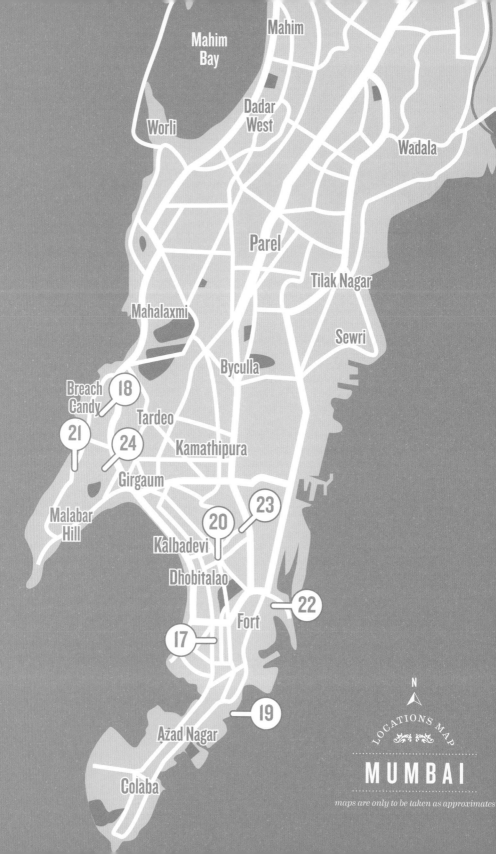

MUMBAI LOCATIONS

SCENES 17-24

MANZIL (1979)

Azad, Cross and Oval Maidans, with Rajabai Tower in the background, Maharshi Karve Road, Churchgate

IN THE POPULAR IMAGINATION, rain symbolizes happiness and romance. Basu Chatterjee's *Manzil* (Destination) tells the story of Ajay (Amitabh Bachchan) and his romance with Aruna (Moushumi Chatterjee) whom he meets at a friend's wedding. Ajay pretends to be a powerful businessman with Aruna and her wealthy father for fear that they will not accept him otherwise. The romance is intense but precariously placed since it involves some degree of deception. In one of the best-known songs of the film, the director drew on Mumbai's monsoon season to poetically stage the power of the romance. 'Rim jhim gire sawan' (Sound of droplets falling in the rainy season) was composed by the late R. D. Burman and penned by Yogesh. Chatterjee used South Bombay's cityscape as the terrain through which the romantic couple walks joyously. The camera captures the rain soaked streets with their cars, red double-decker buses, and pedestrians with their typical black umbrellas. We see apartment blocks with palm trees in the foreground as the couple saunters across Esplanade (now Mahatma Gandhi Road). They make their way through the Azad, Cross and Oval Maidans with the Rajabai Clock Tower visible in the background through the rain. The Rajabai tower was built in 1878 and modelled on London's Big Ben with a combination of Venetian and Gothic style architecture. Cross Maidan, formerly known as Parade Ground, and Azad Maidan are often used for cricket practice and political rallies. *Manzil* mobilizes a rain-drenched city soaked with history, childhood memories and monumental architecture to stage the beauty of the romance.
⟿ Ranjani Mazumdar

(Photo © Ravi Bohra)

Directed by Basu Chatterjee
Scene description: *Ajay and Aruna walk under the monsoon rains*
Timecode for scene: *0:44:50 – 0:48:51*

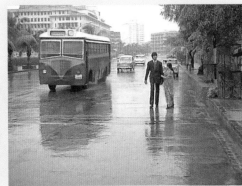

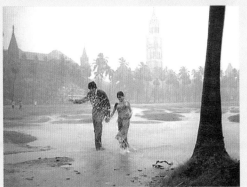
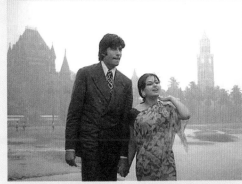

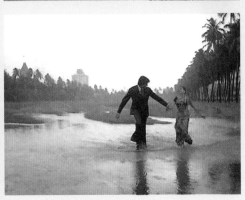
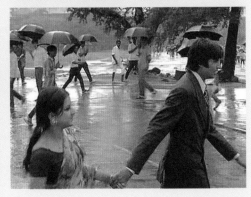

KALYUG (1981)

Mehta House, Bhulabhai Desai Road, Breach Candy

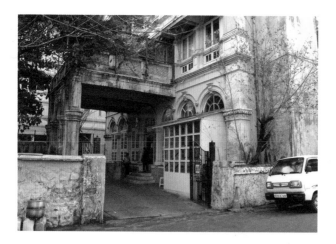

SHYAM BENEGAL'S corporate warfare drama borrows its broad structure and characters from the *Mahabharata*. The epic, about cousins whose differences lead to a soul-destroying war, replaces the Pandavas and the Kauravas with the Puranchands and the Khubchands. The two branches of a prominent trading clan engage in a fight to the finish to snag a valuable government contract. The families live in beautifully appointed mansions and wear the latest threads to breakfast, but cruelty spurts out ever so often through the veneer of gentility. The conviviality that marks a birthday party early in the film is replaced by tension and rancour at a wedding celebration only a few reels later. Dark deeds and death lie in store. Two grand Mumbai mansions serve as the setting for often despicable acts of sordidness. *Kalyug* (Age of Kali) was shot at Mehta House in Breach Candy (where the Puranchands live) and at the official residence of the chairperson of the city's port trust authority (the Khubchand home). While *mise-en-scène* maestro Chandragupta (who worked on Satyajit Ray's films) repainted and redecorated parts of the Port Trust bungalow in Colaba, the Mehta House didn't need much work since it was, and remains, a veritable museum of stone sculptures, prized paintings, and traditional furniture. •➔ *Nandini Ramnath*

(Photo © Vikrant Chheda)

Directed by Shyam Benegal
Scene description: A wedding and the hint of a funeral
Timecode for scene: 0:49:34 – 0:55:27

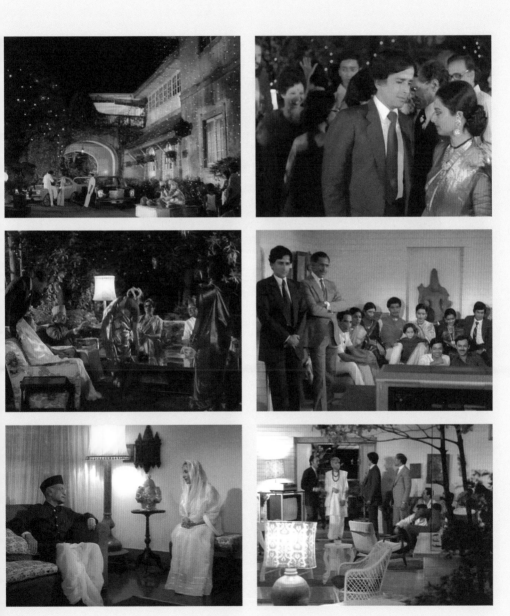

Images © 1981 Film-Valas

GANDHI (1982)

LOCATION *Mumbai port and docks, Mumbai Port Trust, P. D. Mello Road*

AFTER MANY YEARS away from India and successfully challenging British laws in South Africa, Gandhi returns as a national hero on 9 January 1915. His port of entry is Bombay. When he steps down from the ship, two things are clearly apparent: he's not wearing the western attire he sported as a lawyer, and he gets more attention than the new British Military Governor who arrives on the same ship. Young Nehru, who will become India's first prime minister, and Sardar Vallabhbhai Patel, one of the most influential leaders in the struggle for independence, greet him and his wife Kasturba amid a sea of followers. In this sequence Richard Attenborough effectively conveys how the people Gandhi sees on the streets and the leaders he meets on those first few days will provide the introductory lessons to get reacquainted with his country. From then on Bombay will play a key role in Gandhi's life and struggle. He will keep coming back, staying mostly at Mani Bhavan, today a museum devoted to his memory, and where he learnt how to spin the *charkha* (Indian spinning wheel) to make his own clothes. In Bombay he also participated in the first bonfire of clothes made with foreign fabric, and on 8 August 1942 issued his historic Quit India Speech at the Gowalia Tank Maidan, later renamed August Kranti Maidan (August Revolution Ground). It was also from Bombay's port, surrounded by enormous crowds at Ballard Pier, that Gandhi sailed to London for the first negotiations towards India's independence. ⟿ *Helio San Miguel*

(Photos © Vikrant Chheda and Ravi Bohra)

Scene description: *Gandhi returns to India and joins the independence movement*
Timecode for scene: *0:39:35 – 0:44:25*

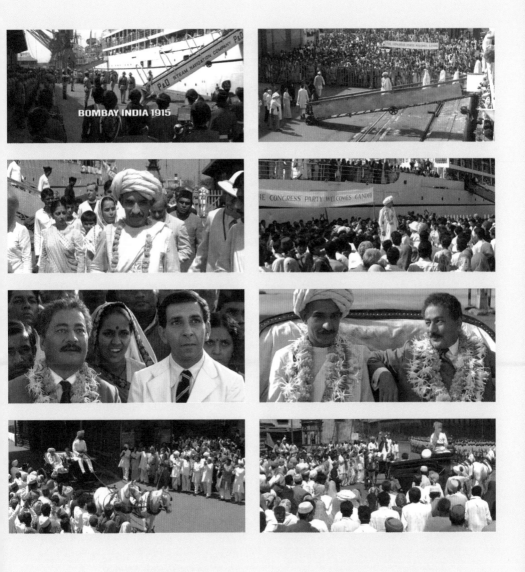

ARDH SATYA (1983)

Mumbai cafes, especially Kyani Cafe and Bakery, JSS Road, Marine Lines

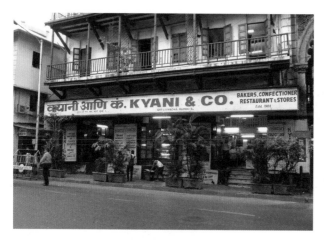

GOVIND NIHALANI changed the direction of gangster films with *Ardh Satya* (Half Truth), a film that can be seen as a forerunner of Mumbai Noir. Written by acclaimed playwright Vijay Tendulkar, it focuses on the growing anxiety of policeman Velankar (Om Puri, in his breakthrough performance) as he fights corruption and the ties between gangsters and politicians, while romancing Jyotsna (Smita Patel), a college lecturer. Mumbai cafes mark Velankar's personal evolution. His epiphany while he reads Dilip Chitre's poem with Jyotsna happens in an upscale cafe facing Marine Drive, and the meetings with his boss regarding his plight take place in Kyani, a centenary Irani cafe. A beloved yet fading institution, Irani cafes offer a calm respite in hectic Mumbai and have served as locations for fights, deals, secret encounters, and lovers' retreats in their 'family rooms'. The Iranis are Zoroastrians, but unlike the Parsis, they came to India only in the nineteenth and twentieth centuries. They soon established their famous cafes in Mumbai, Pune and Hyderabad. They serve Irani *chai* (tea), *bun maska* (buttered bread buns) and traditional foods. Their number is dwindling, threatened by modern cafes, fast food chains, and younger Irani generations who don't wish to follow in the family tradition. Besides Kyani, the most famous are Britannia in Ballard Estate, and Leopold in Colaba, a frequent tourist spot for hippies and foreigners and a target of the 2008 terrorist attacks. Recently Khalid Mohamed, famous critic, scriptwriter and director, made the documentary *The Last Irani Chai* (2011), a delightful and nostalgic tribute to the Irani cafes. **➸ Helio San Miguel**

(Photos © Devrath Sagar)

Directed by Govind Nihalani
Scene description: Mumbai cafes mark Velankar's fate
Timecodes for scene: 0:28:05 – 0:30:50; 0:33:31 – 0:35:18; 0:55:05 – 0:57:31; 1:50:59 – 1:51:56

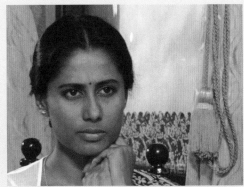

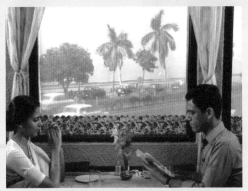
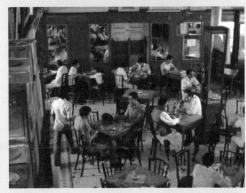

JAANE BHI DO YAARO (1983)

Nepean Sea Road, Malabar Hill

CIVIC COMMISSIONER D'Mello is bending the rules to allow more floors for a high-rise complex than is permissible. Perched inside an open lift that constantly circles the under-construction complex, D'Mello negotiates his rate with Tarneja, the builder, and Tarneja's fixer and secretary. As the lift revolves, Mumbai's landscape comes into and disappears from view. Once the transaction has been completed, the group moves to an unfinished floor that is sheltered from the harsh Mumbai sun. High above the common people and away from prying eyes, four people so shadowy that you can view only their silhouettes clink glasses to a profitable future. Dirty deals struck several feet above the ground (shot at an actual site in Nepean Sea Road) reverberate on the ground level in Kundan Shah's ageless satire. *Jaane Bhi Do Yaaro* (Just Let It Go, Friends), about the seriocomic adventures of two photographers who stumble upon a scam involving government officials and builders, drew from actual events that had made the headlines in the metropolis. Some characters were composites of real people. A shoestring budget meant that Shah and his team (including esteemed editor–associate director Renu Saluja and cinematographer Binod Pradhan) couldn't afford sets, so they shot mostly on location. The all-seeing but ultimately powerless photographers encounter graft wherever they turn – at a park named after the legendary Italian director Michelangelo Antonioni, in the foundation of a flyover built by Tarneja, at a boxy Mumbai-style apartment, and even at the printing press of a scandal-busting tabloid. **❖Nandini Ramnath**

(Photo © Vikrant Chheda)

Directed by Kundan Shah
Scene description: A dirty deal is struck high above the ground
Timecode for scene: 0:15:03 – 0:21:51

MASHAAL (1984)

THE BUSINESS DISTRICT Ballard Estate is home to some of the most striking colonial-era buildings in the city. Named after J. A. Ballard, the first chairperson of the Mumbai Port Trust, and built in the early 1900s by celebrated architect George Wittet, the neighbourhood remains mostly unchanged except for a decline in public hygiene standards that mirrors a situation prevalent across Mumbai. Ballard Estate's stone structures are movie-ready silent witnesses to the tragedy that befalls Vinod Kumar, the hero of *Mashaal* (Flames). Mumbai, famous for its generosity but also notorious for its apathy, turns on Vinod in one of the film's most famous sequences. Vinod (played by thespian Dilip Kumar), an upright newspaper editor, is trying to get his ailing wife Sudha (Waheeda Rehman) to a hospital. Over several excruciating minutes, he tries to stop passing vehicles, growing increasingly desperate as Sudha writhes in a corner. Vinod throws stones on the building that houses the National Union of Seafarers of India, but there is no response. This could very well be because the employees left the building for their homes many hours ago, but we will let that pass. Vinod's 'Ae bhai' (O brother) cry for help has led to some parodying, but there is no denying Dilip Kumar's escalating sense of despair and helplessness as his wife dies in front of him. If there is any one sequence that characterizes the tendency of Mumbaikars to speed away in the opposite direction when a problem rears its head, this is it. ➤*Nandini Ramnath*

(Photo © Vikrant Chheda)

Directed by Yash Chopra
Scene description: *Mumbai robs Vinod Kumar of his wife*
Timecode for scene: *1:40:15 – 1:47:52*

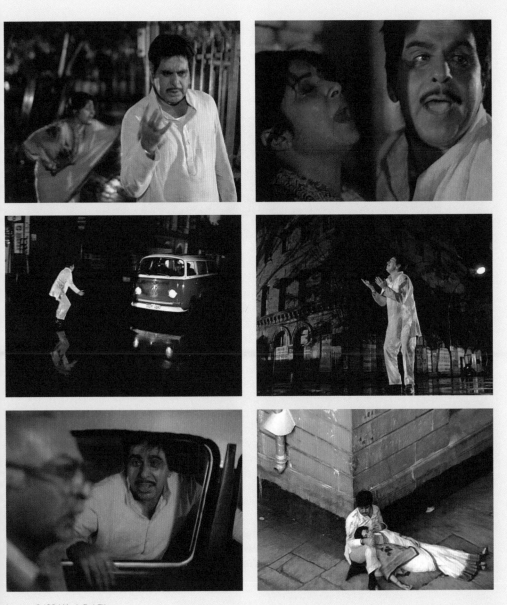

SALAAM BOMBAY! (1988)

LOCATION *Crawford Market (official name: Mahatma Jyotirao Phule Market), Ramabai Ambedkar Marg, Dhobi Talao*

WHILE MAKING HER documentary *India Cabaret* (1985), Mira Nair saw the kids that brought tea to the strippers and the idea for *Salaam Bombay!* was born. In true neo-realist style the film is shot on location on gritty South Mumbai streets and uses mostly non-actors. Real life rag picker Shafiq Syed plays Krishna, a 10-year-old who has been thrown out of his house by his mother over a mere 500 rupees. 'Come back a movie star!' a ticket agent sarcastically tells the boy, as he sells him a train ticket to Mumbai. There, naïve Krishna quickly becomes wily Chaipau, a runner selling tea to drug dealers and prostitutes in the Grant Road red-light district. He finds a family in fellow street kids and a drug pedlar, Chillum. When Chillum is fired from his job and in danger of losing his life to the throes of drug withdrawal, Chaipau works harder to buy him drugs. Trying to make an extra buck, he finds himself in a cage in a Crawford Market poultry shop, scraping bird droppings. The 24,000 square foot market was designed in Norman-Flemish style by British architect William Emerson and completed in 1869. As one of Mumbai's oldest and most famous markets it is perpetually teeming with thousands of Mumbaikars, fighting for elbowroom to buy fruits, vegetable and poultry. The chaos and the restlessness experienced at Crawford Market is not unlike what Krishna finds trapped in his young life; forced to become an adult even before he can experience childhood. **→Devrath Sagar**

(Photos © Devrath Sagar and Helio San Miguel)

Directed by Mira Nair
Scene description: Chaipau and his friends clean birdcages
Timecode for scene: 0:18:10 – 0:19:27

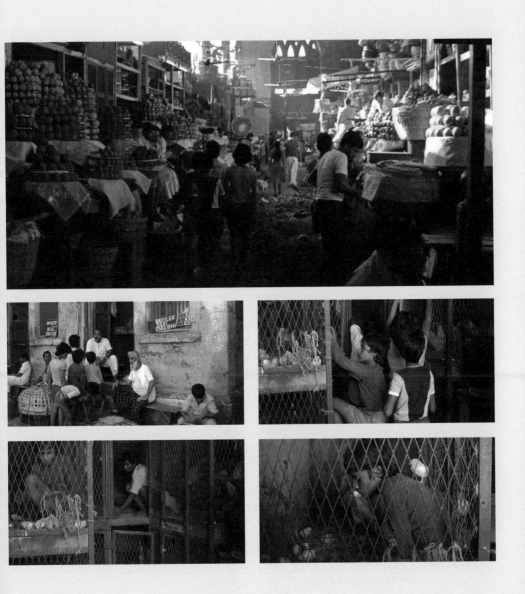

PARINDA (1989)

Babulnath Temple, 16 Babulnath Road, Malabar Hill

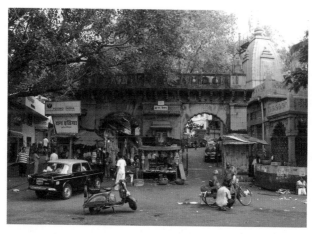

PARINDA (PIGEON) is a classic of contemporary Indian cinema and a precursor of the Mumbai Noir genre. It established the career of director Vidhu Vinod Chopra and helped cement the star status that the leading actress, Madhuri Dixit (who plays Paro), had achieved with her previous film *Tezaab/Tezaab is Acid* (N. Chandra, 1988). She will dominate Bollywood cinema in the 1990s. *Parinda* offers a variation on the typical pattern of many popular Hindi films in which a stranger, frequently a villager, arrives in Bombay only to get corrupted by the big city. This time it's not an outsider, but Karan (Anil Kapoor), who returns home after completing his studies abroad, unaware that his brother Kishen (Jackie Shroff) has become a gangster. Upon his arrival he goes to meet his best friend Prakash, a policeman who is also Paro's brother. Prakash is then shot by the gang Kishen belongs to, and dies in Karan's arms. Karan will be threatened not to identify the killers. Scared, he wants to explain his behaviour to Paro and goes to meet her at Babulnath Temple, a charming late eighteenth century shrine dedicated to the god Shiva and located in Malabar Hill. The angel-like image of Paro feeding the pigeons rekindles Karan's love and awakens memories of their childhood together. But not even in this serene temple will they be able to find peace as prying eyes follow them at every turn. Karan then realizes he must confront the killers and avenge his friend's death. ➻**Helio San Miguel**

(Photos © Vikrant Chheda and Raj Hate)

Directed by Vidhu Vinod Chopra
Scene description: Karan talks to Paro about the murder of her brother
Timecode for scene: 0:49:06 – 0:54:00

MUMBAI NOIR

An Uncanny Present

Text by
RANJANI
MAZUMDAR

FILM NOIR IS AN EXPRESSIVE term initially used to identify a body of crime cinema made in Hollywood between 1940 and 1958. Noir's ensemble of dark streets, shadowy walls and psychologically deranged characters offered a powerful landscape for a dystopic vision of the twentieth century. Today noir is a global form and virtually every major city in this world has been viewed through its filter. Mumbai is no exception. While the aesthetics of expressionistic lighting common to noir has existed in Bombay Cinema for a while (*Mahal* [Kamal Amrohi, 1949]; *Awara* [Vagabond; Raj Kapoor, 1951]; *Baazi* [Guru Dutt, 1951]; *C.I.D.* [Raj Khosla, 1956]), the term Mumbai Noir gained currency only in the 1990s after the release of a few landmark films that directly drew on the stories of the underworld. In a city where the rich and poor live cheek by jowl, where disenchantment is the experience of the majority, Mumbai Noir has become synonymous with urban decay, crime, claustrophobia, and an assortment of characters marked by some sort of death wish.

The first film of the recent past to showcase the aesthetics of noir in its visual structure remains Vidhu Vinod Chopra's *Parinda* (Pigeon, 1989). Kishen (Jackie Shroff) works for a gang lord, Anna (Nana Patekar). Kishen's brother Karan (Anil Kapoor) returns from the United States after completing his education, unaware that his brother is a gangster in the city. Karan is soon sucked into a vortex of violence in a narrative that consciously uses Mumbai's familiar locations like the Gateway of India, the Babulnath Temple, the fountains and various abandoned factories. There is an obsession for the night and for fragmented dark spaces. The three characters have a connected past imbuing the city with memories of childhood. Urban space is not just the backdrop but a central character in the film and the use of the Gateway

of India to stage a bloody climax paved the way for a new imagination of violence.

Seven years after *Parinda*, Sudhir Mishra released *Is Raat Ki Subah Nahin* (No End to This Night, 1996), an unusual existential film about a chance meeting between an advertising executive Aditya (Nirmal Pandey) and a gangster, Raman *bhai* (Ashish Vidyarthi). The film unfolds through one long night involving a series of intense, emotional and violent encounters. Aditya is married to Pooja (Tara Deshpande) but also has a mistress, Malvika (Smriti Mishra). This puts pressure on his marriage. The emotional turbulence faced by all three characters is compounded by a chance encounter with Raman *bhai* in a bar where Aditya ends up slapping the former accidentally. There is mayhem in the city as all the characters get involved in a cat and mouse chase. Mumbai unfolds through the night with its streets, railway tracks, alleyways, dirty bathrooms, decrepit hospitals and swanky apartments on display. *Is Raat Ki Subah Nahin* combined the world of restless and lost souls with a nocturnal cartography of the city, imbuing the narrative with a sense of thrill and adventure.

It was however, the gritty and edgy world of Ram Gopal Varma's *Satya* (Truth, 1998) that really brought the term Mumbai Noir into much wider circulation. *Satya* staged noir's typical sense of 'moral ambiguity' while also drawing much more explicitly on the visual codes of the gangster genre. Shot primarily during the monsoon season, the film narrates the adventures of a migrant named Satya, who arrives in Mumbai from nowhere. He goes to prison on false charges and there he meets the legendary underworld don, Bhiku Mhatre (Manoj Bajpai). The friendship between the two men, their adventures with other gangsters and their personal lives are set amidst an urban wasteland of half constructed buildings,

congested and narrow alleys, unruly crowds and a sea of sweaty bodies. *Satya* deploys the 'aesthetics of garbage' to showcase a landscape of urban detritus. Mumbai is identified via its relationship to rain, unending construction, the Mumbai-Pune highway, and the annual Ganesh Chaturthi festival held to celebrate the birthday of the elephant god, Ganesh. Every year after almost ten days of celebration across the city, thousands of statues of Ganesh are immersed. The largest procession with the biggest statue however goes all the way to Girgaum Chowpatty Beach. It is this annual event at Chowpatty that is used in *Satya* to stage the climax of the film.

Varma's *Company* (2002) was made like a sequel to *Satya* and expanded the gangster form into a syndicate network. The film was inspired by the conflict between two real life gangsters, Dawood Ibrahim and Chhota Rajan, on religious grounds following the 1993 blasts in Bombay. Mallik (Ajay Devgn) and Chandu (Vivek Oberoi) work for an international criminal cartel that runs like a corporation. The film inventively uses the phone to establish the technological highway central to the corporate style functioning of the gang. The film's travel structure links the streets of Mumbai, its police stations, courts and alleyways, to a postmodern landscape of cities such as Hong Kong. The underworld's involvement in real estate and the stock market is the primary focus of the film narrated via the friendship and subsequent estrangement between two gangsters.

In its initial phase, Mumbai Noir became synonymous with gangster themes. Films like *Maqbool* (Vishal Bhardwaj, 2003; an adaptation of *Macbeth*), *Black Friday* (Anurag Kashyap, 2004) and *Johnny Gaddar* (Sriram Raghavan, 2007) continued with the gangster theme but with some modifications. The gangster cycle was broken first by Anurag Kashyap's *Paanch* (Five), a still unreleased film that soon garnered cult following. The film tells the story of five friends in a small-time rock band with a burning desire to make it big. The band kidnaps a friend in the hope that the ransom will allow them to cut a promotional disc. Things go wrong and several people are found murdered. Greed, ambition, passion and sexual desire saturate the film. *Paanch* used architecture and production design evocatively to express a gothic urban landscape. The friends spend most of their time in a decrepit apartment and practise in a basement warehouse. Mumbai is presented through these spaces where ordinary people can suddenly turn violent. *Paanch* became an influential film triggering a series of psychological thrillers. The most influential of these was *Being Cyrus* (2006) directed by Homi Adajania, which relied on the Parsi community's internal dysfunctional world to enter the city of Mumbai. Parsi identity is constructed in the film through interior spaces that become ominous and threatening. Cyrus (Saif Ali Khan) as a quintessential stranger enters the world of a large family and proceeds to kill for no apparent reason. His pleasant demeanour co-exists with his ability to coldly plot and kill, making everyday life appear chilling and sinister.

This exploration of psychic registers and the pervasiveness of violence in everyday life mark the direction of Mumbai Noir today. As Mumbai strives to become a global city like Singapore or Shanghai, the dark side of its industrial past, unemployment and homelessness, continues to haunt its present. The underbelly of India's best-known city has come to the fore in the cinematic archive of Mumbai Noir. ✢

As Mumbai strives to become a global city like Singapore or Shanghai, the dark side of its industrial past, unemployment and homelessness, continues to haunt its present.

Dharavi

27

Mahim

Mahim
Bay

Dadar
West

Worli

Wadala

Parel

Tilak Nagar

Mahalaxmi

Sewri

28

Byculla

Breach
Candy

31 Tardeo

Kamathipura

25

Girgaum

26a

32 Malabar
Hill

30

Kalbadevi

Dhobitalao

Fort

29

26b

N

Azad Nagar

LOCATIONS MAP

MUMBAI

Coloba

maps are only to be taken as approximates

MUMBAI LOCATIONS

SCENES 25-32

SALIM LANGDE PE MAT RO (1989)

Streets in the Dongri area around Mohammed Ali Road

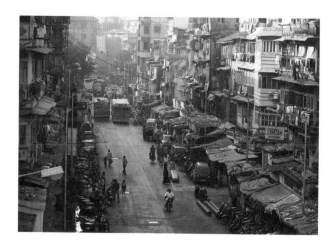

IF SOMEONE DESERVES the title of director of Mumbai, a strong candidate would be Saeed Akhtar Mirza. From his early films all the way to *Ek Tho Chance* (2011) his films and TV series have covered all the communities and main conflicts of the city. With *Salim Langde Pe Mat Ro* (Don't Cry for Salim the Lame) he made his most personal film ('my own self, split 500 times' as he has often been quoted) addressing the issues of Muslim identity in modern India. Set in the period between Mumbai's two most conflicting events in recent history, the textile mills strike of the 1980s and the 1992–93 communal riots, it follows the wanderings of Salim (Pavan Malhotra), a petty criminal, as he negotiates the daily existence for himself and his family through the poor and crime infested Muslim area where they live. Mirza's films frequently chronicle the personal and ideological transformation of a character who takes action at the end. Here the catalyst for Salim's change is his sister's fiancé Aslam, an idealistic and educated Muslim. But when Salim decides to change the course of his life and gives up his gang activities, he is stabbed during his sister's wedding celebrations. The film was shot in the reputedly dangerous streets of Dongri and the nearby areas of Bhendi Bazaar and the famous Chor Bazaar (Thieves Market) in South Mumbai. These same neighbourhoods served as a location for the recent *Bhindi Baazaar Inc.* (Ankush Bhatt, 2011), where Malhotra also acts.
➻ Helio San Miguel

(Photo © Sunhil Sippy)

Directed by Saeed Akhtar Mirza
Scene description: Salim is stabbed at his sister's wedding celebrations
Timecode for scene: 1:40:21 – 1:44:53

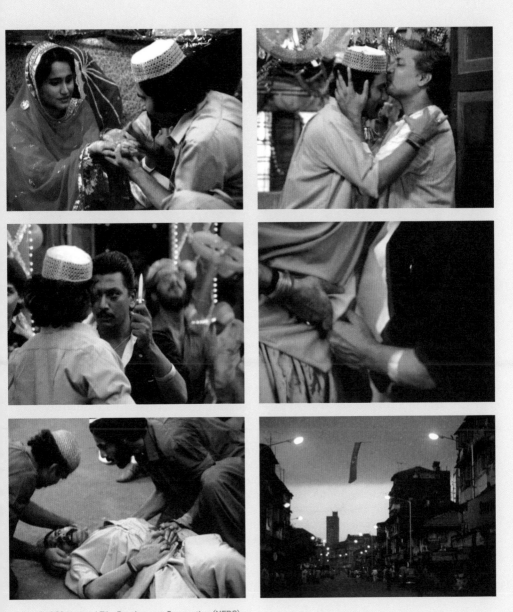

Images © 1989 National Film Development Corporation (NFDC)

NAZAR (1991)

Khotachi Wadi, Girgaum, and Nariman Point

SINCE *USKI ROTI/OUR DAILY BREAD* (1970), Mani Kaul became one of the most important film-makers of the Indian New Wave. *Nazar* (The Gaze), made two decades later and based on Dostoyevsky's *The Meek One* (1876), was his first fiction film since *Duvidha* (1975). It chronicles the growing isolation of a young woman (Shambhavi; the director's daughter) who is married to a middle-aged antique dealer (Shekhar Kapur; the famous director of *Bandit Queen* [1994] and *Elizabeth* [1998]). Kaul composes this poetic, non-linear film with slow scenes that work as impressionist brush strokes that only at a distance allow us to see the whole picture. He subtly expresses the opposition between the couple through the choice of their habitats, two not so distant, but very different areas in South Mumbai. Most of the film takes place in the husband's modern and open apartment. From its terrace and windows we glimpse at a few prominent buildings (the Taj Hotel, the State Assembly, Mumbai's World Trade Centre, etc.) that establish its location around Nariman Point, Mumbai's business district, developed since the 1970s on reclaimed land. However, when he visits his prospective wife, her house is located in Khotachi Wadi, a delightful little area built in distinctive nineteenth century Portuguese-style small houses inhabited by a Christian community and constantly under siege by Mumbai's vertical growth. Despite its airy and luminous atmosphere, Kaul manages to convey that the modern apartment is ultimately more claustrophobic and unbearable than the secluded environment of Khotachi Wadi. ➡ ***Helio San Miguel***

(Photos © Helio San Miguel and Vikrant Chheda)

Directed by Mani Kaul
Scene description: An antique dealer visits a young woman at her house / The couple at his home
Timecodes for scene: 0:12:26 – 0:21:49 and 0:52:53 – 1:09:36

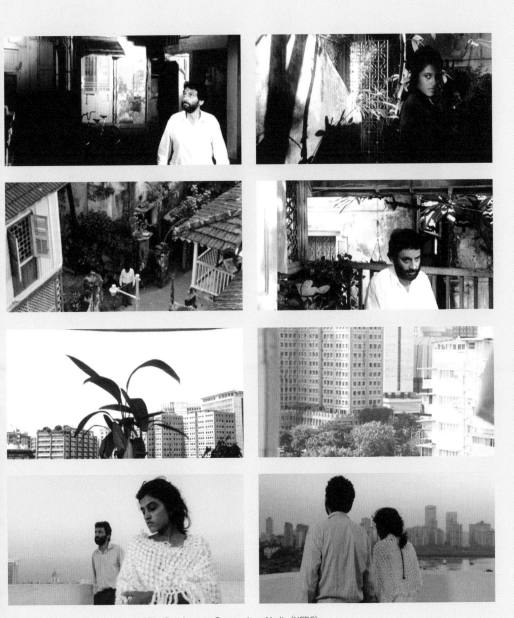

DHARAVI (1992)

Dharavi, Central Mumbai

DHARAVI, FAMOUSLY DEFINED as 'the biggest slum of Asia', with over half a million residents crammed into less than 200 hectares, may no longer be the largest in Mumbai. However, it has become a symbol of the bleak living conditions that affect over half of the city's population. Whether it is portrayed as a representation of horrifying poverty, depicted as a battlefield of gang violence and political struggles, or praised as a model of informal economy (it has thousands of small factories specialized in pottery, leather, textiles and recycling industries), Dharavi has a rich cinematic presence. It appears, among many others, in documentaries like *Hamara Shahar/Bombay, Our City* (Anand Patwardhan, 1985), *parallel* realist films like *Chakra* (Rabindra Dharmaraj, 1981), famous Tamil gangster films like *Nayakan* (Mani Ratnam, 1987), and in *Slumdog Millionaire* (Danny Boyle and Loveleen Tandan, 2008). Sudhir Mishra's *Dharavi* also casts a realistic look at the slums through the life of Rajkaran (Om Puri), a taxi driver split between the harsh reality of his daily existence and his dreams fuelled by visions of Bollywood star Madhuri Dixit. Suketu Mehta writes in *Maximum City: Bombay Lost and Found* (2004, p. 539) that humans tolerate living in the squalor of the slums because their dreams inhabit palaces. But unfortunately those visions rarely materialize. Rajkaran decides to take a risky loan to operate a little cloth-dyeing factory, but it is soon demolished. His dreams, like those of many others, are shattered too. Mumbai's slums remain an open wound in a city that, like Rajkaran, has grand visions of becoming London or New York. **⟿Helio San Miguel**

(Photo © Raj Hate)

Directed by Sudhir Mishra

Scene description: Rajkaran's dreams are shattered when his little factory is torn down

Timecode for scene: 1:14:07 – 1:16:39

MAMMO (1992)

IN THE AFTERMATH of the 1992–93 riots, acclaimed film-maker Shyam Benegal partnered with Khalid Mohamed to explore the situation of the Muslim minority in a film trilogy centred around the lives of three women, *Mammo, Sardari Begum* (1996) and *Zubeidaa* (2001). Mohamed wrote the screenplays infusing them with family reminiscences. In *Mammo*, Riyaz (Amit Phalke), a young teenager, lives with his grandmother (Surekha Sikri) in 1970s middle-class Bombay. He wants to be a writer, plays classical music to his fish, and is so crazy about Hitchcock that he wears a burkha to gain entrance to see *Psycho* (1960). Suddenly his grandmother's sister, Mammo (Farida Jalal), arrives from Pakistan after the death of her husband with the intention of staying. She eventually wins Riyaz over, but at first he resents her presence and vehemently confronts her, and she leaves the house. They finally find her in Mumbai's most striking mosque, Haji Ali. Erected in 1431, it houses the tomb of saint Haji Ali Shah, a merchant from Bukhara (now in Uzbekistan) who gave up his wealth and left for Mecca. His body was found on an islet almost 500 metres off the coast, and the mosque was erected there in his memory. When high tides cover the narrow passageway leading to the mosque, it appears to float on the sea. Its beauty makes it a frequent film location, but here it also serves as an expressive metaphor for Mammo's plight and the sense of isolation often felt by many Indian Muslims.
⊷ Helio San Miguel

(Photos © Raj Hate and Vikrant Chheda)

Directed by Shyam Benegal
Scene description: Riyaz and his grandmother find Mammo at the Haji Ali mosque
Timecode for scene: 1:28:56 – 1:34:47

BOMBAY (1995)

LOCATION *Gateway of India, Apollo Bunder*

THE GATEWAY OF INDIA is perhaps one of the most iconic structures of Mumbai, built by the British in 1924 as a ceremonial entrance to the city. Since then, it is the most popular tourist site along with the nearby Taj Mahal Hotel. The photographic form of the structure has circulated widely and cinema has tended to proudly display the site. In Mani Ratnam's *Bombay* based on the 1992–93 riots following the demolition of Babri Masjid, the Gateway is used quite differently. A Hindu man (Arvind Swamy) and his Muslim wife (Manisha Koirala) give birth to twins. Ratnam uses a song to show the transition from birth to childhood. The mixed marriage family and their happy state are presented in the form of a montage of visuals in and around the Gateway. The pigeons right outside, the little boys running to the waterfront, and the couple framed under the archway, are all woven into the montage as the song reaches a crescendo. But at no point do we see the full shot of the Gateway. It is as if the director consciously sought to defy its monumental significance as a tourist site. Perhaps for Ratnam a touristic imagination would block any perception of the conflicts located in the heart of the city. The happy moment at the Gateway changes rapidly as the city gets engulfed by riots. The children are lost and the parents relentlessly search for them in the midst of the violence and destruction. The Gateway sequence functions in *Bombay* as a gateway to a violent city.
➻Ranjani Mazumdar

(Photos © Vikrant Chheda and Sunhil Sippy)

Directed by Mani Ratnam
Scene description: *Happy times with the kids, just before the riots*
Timecode for scene: *1:17:04 – 1:18:19*

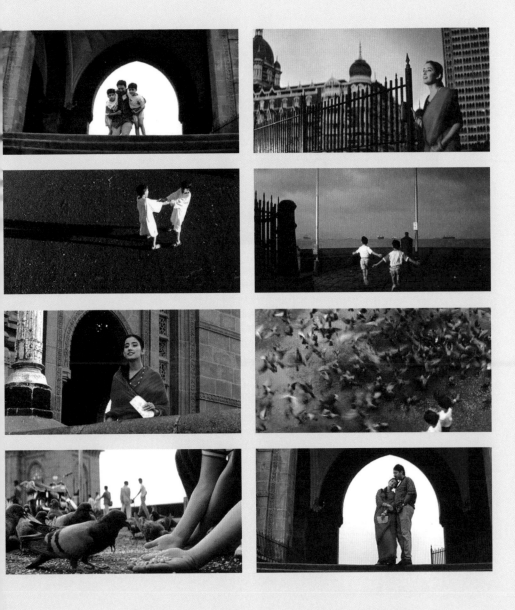

SATYA (1998)

Chowpatty Beach, Marine Drive, Girgaum

THE TWIN SHADOWS of Martin Scorsese and Francis Ford Coppola hang over Ram Gopal Varma's *Satya* (Truth), one of the finest gangster films in Hindi cinema. Scorsese's influence is evident in the macho posturing and profane speech patterns of the various characters who populate the story of the rise and fall of a gangster. Coppola's ghost haunts the moment when the eponymous anti-hero avenges the death of his mentor, Bhiku. Varma borrows the idea of marrying the sacred and the profane and setting a murder amidst a religious procession from *The Godfather: Part II* (1974). Satya follows Bhiku's killer, the politician Thakurdas Jhawle, to Girgaum Chowpatty beach, where Jhawle and his followers are immersing a Ganpati idol to mark the end of the annual festival of the elephant-headed deity. There is even a touch of Bernard Hermann's score from *Psycho*'s (Alfred Hitchcock, 1960) shower sequence in the moments when Satya winds his way through a packed procession, catches Jhawle's attention and then stabs him in the stomach. The expertly edited sequence, which splices together top-angle shots with ground level tight frames, was shot at two separate beaches. The scene begins with long shots of an actual Ganpati immersion at Girgaum Chowpatty. For the rest, Varma did another shoot with the actors on the same beach. He also shot many months later with a replica of the idol seen in the beginning at Juhu Chowpatty in north Mumbai. The city's main beaches are places where families feast on local savouries, lovers snuggle up to each other, and masseurs stalk customers. In Varma's telling, the beach is a setting for ungodly vengeance.

↝ *Nandini Ramnath*

(Photo © Vikrant Chheda)

Directed by Ram Gopal Varma
Scene description: Satya avenges the death of his friend
Timecode for scene: 2:37:25 – 2:42:42

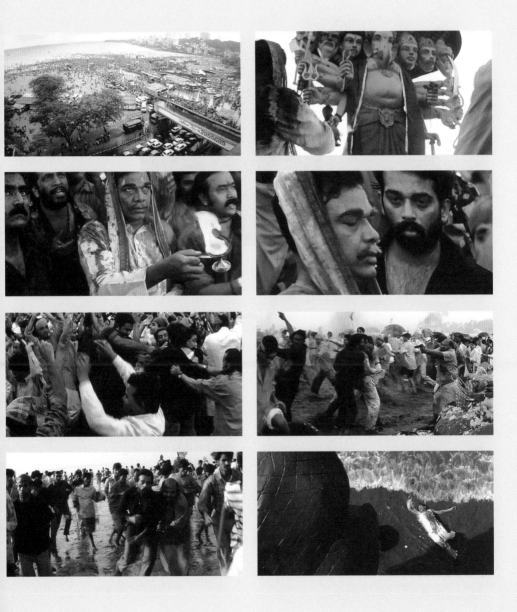

Images © Ram Gopal Varma

SUCH A LONG JOURNEY (1998)

LOCATION *Cama Building, Tardeo*

BASED ON THE HOMONYMOUS novel by Rohington Mistry (1991), *Such a Long Journey* is a delightful and touching film about Parsis in 1971 Bombay. Parsis are descendants of a group of Zoroastrians who immigrated to India from Iran over 1,200 years ago to avoid persecution by Muslim invaders. Accounting for less than 70,000 of the city's over 20 million inhabitants, the tiny community's impact on the city's culture and architecture far outweighs their numbers. Today, most Parsis in Mumbai live in their own exclusive housing communities. An apartment complex in the Tardeo Parsi colony provides the setting for this character drama to unfold. Bank clerk Gustad Noble, the unofficial mayor of his building, is a simple, earnest and resilient man whose petit-bourgeois life turns out to be anything but simple. Not only is he plagued with household problems such as his wife's resentment, son's rebellion and daughter's illness, but he is also caught up in a money-laundering scheme masterminded by his old friend and secret service agent, Billimoria, to fund the Bangladeshi revolt preceding the India-Pakistan war. Gustad's resilience is finally broken in the climax scene as Tehmul, a mentally challenged resident, is accidently killed in a clash between the citizens of the locality and the municipal government over the demolition of their beloved compound wall which is covered with painted pictures of deities. *Such a Long Journey* is as packed with emotion and information about middle-class India, Parsis, and the political climate of the period, as the crowded streets of Bombay depicted in the film. **⤳Devrath Sagar**

(Photo © Vikrant Chheda)

Directed by Sturla Gunnarsson
Scene description: Battle over the compound wall
Timecode for scene: 1:41:24 – 1:46:02

FIZA (2000)

LOCATION *Banganga Tank and Walkeshwar Temple, Teen Batti, Malabar Hill*

KHALID MOHAMED'S *Fiza* is the story of a woman (Karisma Kapoor) whose brother Aman (Hrithik Roshan) disappears after the 1993 blasts in Mumbai. After six years of waiting, Fiza decides to look for him only to discover that he has now become a hardened terrorist. This tragic tale draws its emotive charge from the experiences of many Muslim families after the 1992–93 riots. The city of Mumbai is creatively deployed to push the film's narrative. In a romantic sequence between Aman and his girlfriend Shenaz (Neha), the director imaginatively produces a creative geography of the city through the eyes of the couple as they sing and dance to the popular song 'Aaja Mahiya' (Come to Me, My Love). The song's climax is staged at the Banganga Tank, an ancient water reservoir built in 1127 AD that is part of the Walkeshwar Temple complex in Malabar Hill. Legend has it that a thirsty Rama shot an arrow (*baan*) to the ground and water from the distant Ganges River sprung up there. In *Fiza*, Banganga is colourfully cast as we see brightly coloured sheets left by washerwomen on the steps to dry. The two lovers are first shown lying down on the steps and then dancing on the platform surrounding the tank. The sheets hanging on a clothesline now fly in the air in the background as Aman and Shenaz run towards the camera in slow motion. In this carefree, endearing and tranquil state, the lovers appear to possess Mumbai. But this is soon destroyed as the city becomes increasingly alienating for Aman, leading him to the path of terrorism.
➻Ranjani Mazumdar

(Photo © Vikrant Chheda)

Directed by Khalid Mohamed
Scene description: Joyous times for Aman and Shenaz before peace is shattered
Timecode for scene: 0:56:26 – 0:57:32

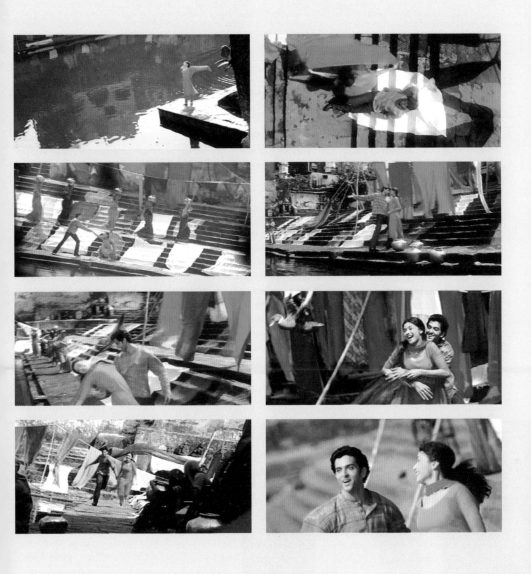

Images © 2000 The Culture Company, UTV Motion Pictures

BOMBAY, POST 6 DECEMBER 1992

Space and Time of Communalism

Text by
LALITHA
GOPALAN

AS IS THE CASE WITH narrative cinema, its relationship to topicality is often belated; documentary and actualities are quick to record and broadcast the events as they are unfolding. However, narrative cinema prefigures the shape of events that is most visible in the sequencing of shots and arrangement of points of view through its long engagement with genre structuring; gangster films, family melodrama, political drama and so on constantly revise their plots by drawing on news events and this is the case with narratives of Bombay Cinema. Certain events that tore the fabric of the secular national imaginary are deemed traumatic and their reckoning surfaces in Bombay Cinema: the razing of Babri Masjid by right wing Hindu extremists, 6 December 1992. Television shaped this event as is evident in several feature films where protagonists are aghast or goaded into more action by the minute-by-minute television reporting. In *Bombay* (Mani Ratnam, 1995), *Zakhm* (Wound; Mahesh Bhatt, 1998), *Naseem/ The Morning Breeze* (Saeed Akhtar Mirza, 1995), *Hey Ram* (Kamal Hassan, 2000), and *Rang De Basanti* (Colour it Saffron; Rakeysh Omprakash Mehra, 2006), television and its acoustics

turn protagonists into passive witnesses or active agents in the unfolding of communal antagonisms as riots. The visual quotations from television suggest the medium's culpability in flaming violent action; as an event that is yet to be re-enacted in narrative cinema, the actual razing of the seventeenth century mosque has the weight of a traumatic event that can find no redress in narration except as quotations from another medium. While narrative cinema has yet to upstage television's original broadcasting of the spectacular aspects of the demolition of Babri Masjid, its lens has turned extensively to filming riots and the Bombay bomb blasts that followed on 12 March 1993. The film that most elaborately visualized the riots is Mani Ratnam's *Bombay* in which weapon-wielding crowds of men run through narrow lanes of the city; automobiles are set on fire; acrid smoke clogs our viewing of charred bodies and detritus; and long scenes in hospitals and morgues; in short through a cinema of special effects we are offered a 'cinema of ruins', a term borrowed from Ranjani Mazumdar's *Bombay Cinema: An Archive of the City* (2007). These sequences of rioting structure the second half of Ratnam's film where, at times, they are marooned from the narrative and imitate documentary style film-making. It has become evident that censorship regulations weigh in on the filming of such sequences and most pointedly regulate the point of view: cops shooting at bystanders or aggressively into crowds were excised from *Bombay* and there was an attempt to depict the logic of attacks and counter attacks between parties 'even-handedly'. In *Zakhm*, for instance, censorship regulations are pre-empted by directing us to see smoke clogged lanes from a protagonist's point of view in a car, the impression conveyed to us is of an autochthonous marauding that has been unleashed into the city despite the

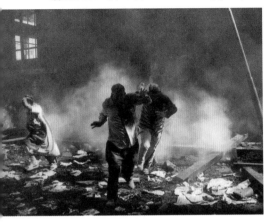

film's preoccupation with antagonisms between Hindus and Muslims.

It's worth remembering that the filming of raiding men and police brutality before the razing of Babri Masjid have long been a mainstay of different genres: N. Chandra's films chronicle lumpen youth on a rampage through neighbourhoods; and the political dramas of Govind Nihalani, are unstinting in their depiction of police brutality. Both styles of film-making inflect *Bombay* and *Zakhm* in their insistence on verisimilitude shaping action sequences, but they break new ground in their reworking of the love story by dwelling on the marriage between a Hindu man and a Muslim woman, a coupling that *Zakhm* reminds us suffered a long silence in Hindi cinema and *Bombay* suggests is the utopian holdout against communal antagonisms.

Since *Hiroshima Mon Amour* (Alain Resnais, 1959), we have grown accustomed to one traumatic event recalling another. So, it's not surprising the horror of witnessing the demolition of the mosque in 1992 recalls the mayhem of partition in the subcontinent, 1947. *Naseem/The Morning Breeze* details a young granddaughter dodging hoodlums on a rampage through Muslim neighbourhoods on her way home; her invalid grandfather who holds court while lying in bed reminisces about his college days of nationalist aspirations in the midst of colonial rule. As the film shuffles between the tensions of living as a Muslim-identified citizen in Bombay, and the halcyon days of amity and debate in Aligarh Muslim University, we as viewers are reminded of possibilities not visited on-screen: not since *Mere Mehboob* (Harnam Singh Rawail, 1963) have we seen images of the student community of Aligarh. Additionally, large sections of the scenes in the household recall another canonical film of this genre, *Garm Hava/Scorching Winds* (M. S. Sathyu, 1975), in which the question of partition tears apart a Muslim family in Uttar Pradesh.

Flashbacks also structure *Zakhm*. Narrated from the elder son's point of view, the flashbacks reveal the mother's closeted Muslim identity and her unsanctioned marriage to the sons' Hindu father. The film lists a price for such secrecy, which begets misrecognition: the mother is attacked by marauding mobs while her hot-headed younger son is a Hindu activist leading a pogrom against Muslims. *Black Friday* (Anurag Kashyap, 2004) takes a different tack: the Bombay serial bomb blasts of 12 March 1993. Anurag Kashyap's controversial film, which ran afoul of censorship regulations, shifts the discourse from communal antagonism to international terrorism. The dramatic potential of bomb blasts has gripped film-makers: Ram Gopal Varma toured the Taj Mahal Hotel after the 26 November 2008 attacks only to be reprimanded for indulging in disaster tourism.

It appears that communal antagonisms seep through films that are committed to being topical, genre notwithstanding. In *Bhoot* (Ghost; Ram Gopal Varma, 2003), a horror film set in a high-rise building, we watch a young couple make love in their new duplex apartment to the sounds of television reporting in an off-screen space. The newscaster's breathless voice informs us of an unravelling pogrom against Muslims onsite, in Godhra, 2002. Attending to the soundtrack allows us to read how their lovemaking is already infected by communal antagonism, temporally antecedent to the film's focus on the haunting horrors experienced by the couple. *Bhoot* reminds us that once aroused, we cannot exorcize communalism from Bombay Cinema. We are just doomed to vigilance. ✦

Certain events that tore the fabric of the secular national imaginary are deemed traumatic and their reckoning surfaces in Bombay Cinema: the razing of Babri Masjid by right wing Hindu extremists, 6 December 1992.

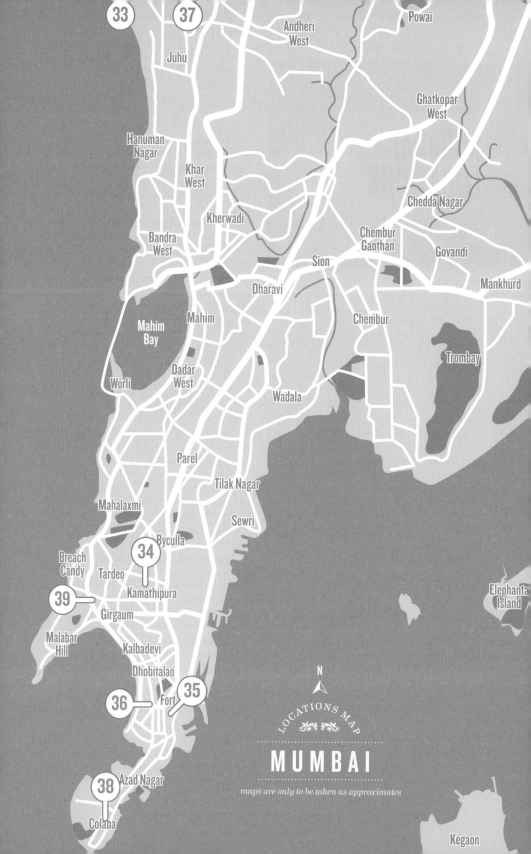

MUMBAI LOCATIONS

SCENES 33-39

CHANDNI BAR (2001)

Market at Versova Fishing Village, Andheri West

IN THIS GRITTY, realistic film devoid of song and dance, Mumtaz (Tabu) leaves her village with her uncle after her parents are killed in communal riots. A shot of CST signals their arrival to Mumbai, the city that 'never puts anyone to sleep on an empty stomach'. Mumtaz reluctantly starts dancing at Chandni Bar and ends up marrying a gangster who is shot in one of the infamous police 'encounters'. She struggles to send her two kids to school and to bring them up far from gangsters and bars. But one day her studious teenage son Abhay is mistakenly arrested. The shadow of his father looms large and he's sent to jail where he's raped. Once out, Abhay takes revenge by killing the two men who abused him. Mumtaz witnesses the scene, shot at the market in Versova Fishing Village. Bhandarkar keeps the camera on her, frozen, shocked, and then slowly crouching down to cry desperately. Her voice tells us 'I wanted to see my future in my children but I only found my past in them.' The elegant long take and Tabu's fine performance eloquently express the tragic collapse of her dreams for a better life for her kids and a cruel social determinism that denies the underprivileged a chance to be anything but what they are. In *Chandni Bar*, Mumbai will not let you go to sleep on an empty stomach, but ingrained corruption, pervasive prejudice, and a static view of the human condition, will once again make your past become your destiny. **↝ Helio San Miguel**

(Photo © Raj Hate)

Directed by Madhur Bhandarkar
Scene description: Mumtaz witnesses her son killing the two men who raped him in jail
Timecode for scene: 2:24:30 – 2:28:20

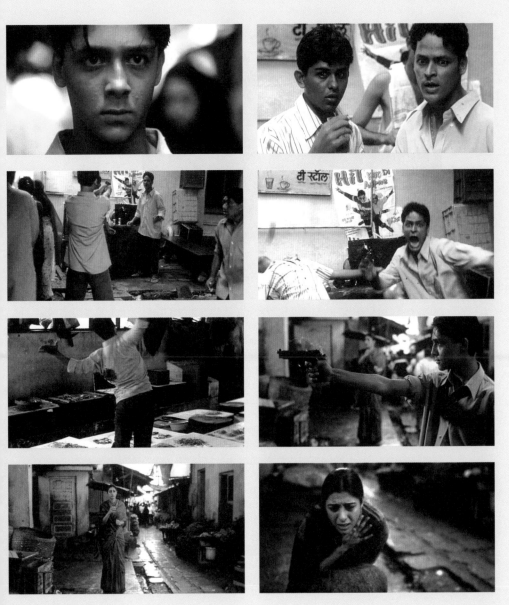

Images © 2001 Lata Mohan

THE FIVE OBSTRUCTIONS (2003)

Kamathipura Lanes, Kamathipura (Falkland Road)

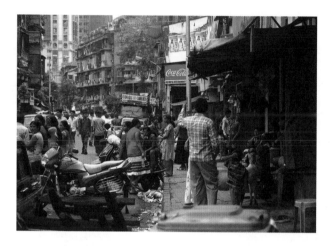

THE FIVE OBSTRUCTIONS depicts an intellectual game between acclaimed and controversial director Lars von Trier and film-maker Jørgen Leth whose enigmatic short *Det Perfekte Menneske/The Perfect Human* (1967) von Trier admires. He challenges Leth to remake it five more times imposing different restrictions. For the second one he stipulates that Leth shoots the sumptuous meal scene in a most miserable place without showing the location on-screen, and also that he acts in it. Leth vividly remembers Mumbai's red light district in Kamathipura and decides to film there. Divided into fourteen lanes, it's the oldest in Asia, and prostitutes, sometimes very young and from different ethnicities, can be seen in cages and behind bars amid horrifying human and urban decay. A translucent plastic sheet was used to isolate the scene, allowing us to see the people behind it. The effect is hypnotic. While they seem amused, we witness it quite horrified at the dramatic contrast. That plastic sheet becomes a metaphor of striking visual power symbolizing all the screens (windows, TVs, computers, car windows) through which we look at underprivileged people, not just in Mumbai but also around the world. We, good-hearted spectators, watch them from the other side, distressed at the unfairness of their situation, but also comfortably eating our meals. When von Trier sees the film, he rejects it for not fully complying with his rules. And he is right. What Leth did is something much more profound. He cleverly subverted von Trier's perverse obstructions to infuse with deeper meaning what started off as just a formal game. ➥ *Helio San Miguel*

(Photo © Vikrant Chheda)

Directed by Jørgen Leth and Lars von Trier
Scene description: Jørgen performs 'the perfect human' in Mumbai's red-light district
Timecode for scene: 0:28:22 – 0:35:04

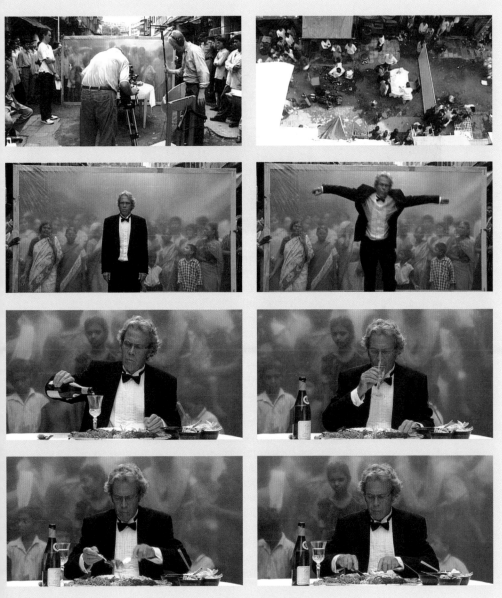

Images © 2003 Almaz Film Productions, Panic Productions, Zentropa Real ApS

BLACK FRIDAY (2004)

Bombay Stock Exchange, P. J. Towers, Dalal Street, Fort

BETWEEN DECEMBER 1992 and January 1993 almost a thousand people, many in Bombay and mostly Muslim, died in brutal communal riots. Underworld don Dawood Ibrahim financed and orchestrated retaliatory actions. On Friday, 12 March 1993, a bomb blast shattered the Bombay Stock Exchange, India's financial heart, located in the Fort area. Twelve more explosions followed all over Bombay setting the city on fire. Chaos ensued and over 250 people were killed. Those tragic events delivered a serious blow to Bombay's cosmopolitan image, and left a deep physical and psychological wound still not yet completely healed. The 1992–93 events, along with the several terrorist attacks that have followed since, are also responsible for a mini genre of films focusing on communal violence and terrorism. *Black Friday* is one of its major works. The director already had previous encounters with the Central Board of Film Censors and *Black Friday* suffered the same fate. Its opening was delayed for two years since the case was still under investigation when the film was shot. For this first blast Kashyap washes the scene with a blue tinge, slow motions the actions of the people in the streets, and most importantly, deletes any human voice and sound from the soundtrack, save for a heartbeat that grows in intensity as the camera approaches a window soon to be shattered. The effect is spellbinding. The dehumanizing nature of terrorism and its blindly destructive consequences are shown in stark yet powerfully long-lasting images and sounds. ➥*Helio San Miguel*

(Photo © Vikrant Chheda and Ravi Bohra)

Directed by Anurag Kashyap
Scene description: First bomb blast at the Bombay Stock Exchange
Timecode for scene: 0:04:06 – 0:14:04

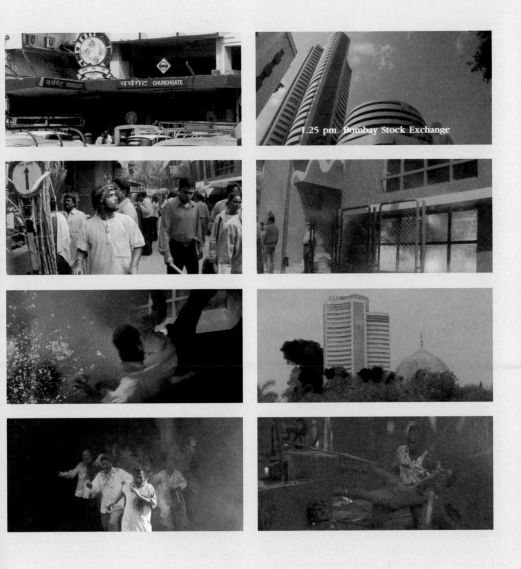

DOMBIVLI FAST (2005)

LOCATION

Churchgate Station, Indian Merchants Chamber Marg, Churchgate

DOMBIVLI FAST, a Marathi film, narrates the story of a bank clerk, Madhav Apte (Sandeep Kulkarni), who spends hours travelling by train to the heart of the city every day for work. One day the protagonist goes berserk when his inner world snaps and takes over. As a vigilante figure, Apte proceeds to fight the corruption in the city by taking the law into his own hands. *Dombivli Fast's* opening train sequence is preceded by scenes of Apte and his family at home. On the train, he listens to the chatter of the commuters and occasionally reads. He works operating a cash-counting machine and a computer everyday, eats his lunch alone, and then walks to Churchgate station to take the train back home. One of the world's busiest stations located in Mumbai's Fort area and built at the end of the nineteenth century, Churchgate is used by more than 3 million passengers daily. Apte is one of the 3 million passengers whose catalogue of itineraries is mundane. His body is consumed by this suburban pace and rhythm, with absolutely no time for anything else. Nishikant Kamat (who later directed the Hindi film *Mumbai Meri Jaan/Mumbai My Life* [2008] about the July 2006 train bombings) builds the train sequence cinematically to show Apte's almost mechanical movement shaped by visual impressions of jostling crowds, the blur of the cityscape, and a noisy soundscape of trains, cash machines, and the din of the city. The obligatory nature of daily travel generates a listless drift; the only change in Apte's facial expression occurs when he sees the yellow signs announcing the departure or arrival of the train at Churchgate station. **✦Ranjani Mazumdar**

(Photo © Vikrant Chheda)

Directed by Nishikant Kamat
Scene description: Apte's frantic daily routine: home-station-work-back home
Timecode for scene: 0:00:40 – 0:04:28

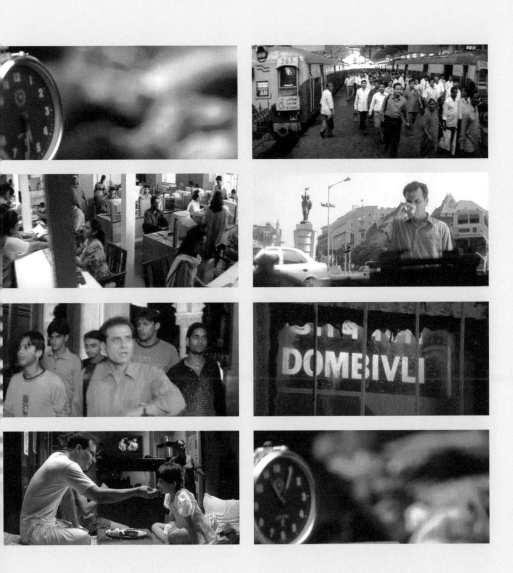

JOHN & JANE (2005)

4th Dimension Call Centre, Malad

JOHN & JANE is a disturbing, yet entertaining insight into the human side of the Indian call centre industry. The film, shot on 35 mm in highly controlled compositions, with a hypnotic electronic soundscape, blurs the line between documentary and science fiction. After a year spent researching 40 employees in a Mumbai call centre, director Ashim Ahluwalia chose Glen, Sydney, Osmond, Nikki, Nicholas and Naomi to be his subjects. The film journeys through portraits of each of the characters suffering from different levels of delusion about their own identities. Indians by day and taught to be Americans by night, they are stuck in a cultural twilight zone between the two countries and two cultures. Naomi is the most extreme example. She bleaches her skin white and dyes her hair (down to her eyelashes) blonde. Speaking in a robotic, confused southern American twang she repeatedly insists that she is 'totally naturally blonde'. Her identity lost to globalization in India, she has no answer when asked where she comes from. Her portrait is the most heart wrenching in the film and makes one question the psychological effects this business has on its employees. With hundreds of thousands of jobs being outsourced from the West to scores of call centres dotted across the major cities in India, the industry has been at the heart of controversy since its inception. On the surface it is an economic boon for the country, but *John & Jane* explores the dark underbelly of its impact on India's youth. **⁌Devrath Sagar**

(Photo © Devrath Sagar)

Directed by Ashim Ahluwalia
Scene description: Naomi's life at the call centre
Timecode for scene: 0:57:30 – 1:10:30

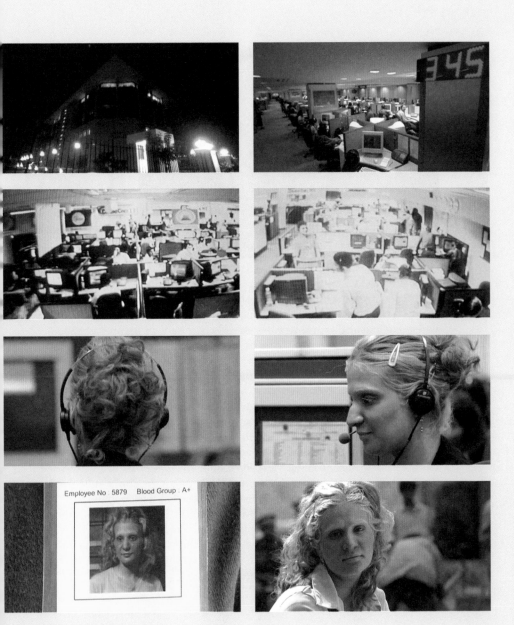

Employee No : 5879 Blood Group : A+

NO SMOKING (2007)

LOCATION *Mukesh Mills, Colaba*

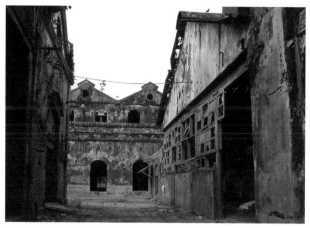

BLACK FRIDAY (Anurag Kashyap, 2004) is usually held up as Counter-Bollywood guru Anurag Kashyap's definitive Mumbai film, but that honour should go to *No Smoking*. Kashyap's daringly independent film, which baffled critics and viewers alike, can be seen as an allegory about his attempts at the time to fit into mainstream Bollywood. The perfectly cast model-turned-actor John Abraham plays K, a self-centred nicotine addict who signs up for a de-addiction programme that comprises a series of torture sessions. K lives in a high-rise that kisses the sky, but his de-addiction laboratory, creatively imagined by production designer Tariq Umar Khan, is situated in an airless netherworld in Dharavi. The den, which resembles a concentration camp, is run by burkha-clad women and men dressed in lungis. When K meets his nemesis, the priest-like Baba Bangali, he is presented with a guide to quit smoking that is about thrice the size of the average encyclopaedia. Bangali's lair was built at Mukesh Mills, a derelict structure in the area of Colaba that has been used in several features, notably by Mukul S. Anand, and advertising films. K's inability to kick the smoking habit seems to mirror Kashyap's stubborn insistence on making films his way. It ends badly for K but not for Kashyap – he is now counted as one of the most noteworthy film-makers working in Mumbai. •*Nandini Ramnath*

(Photos © Raj Hate)

Directed by Anurag Kashyap

Scene description: *K goes to the de-addiction laboratory*
Timecode for scene: *0:29:04 – 0:39:30*

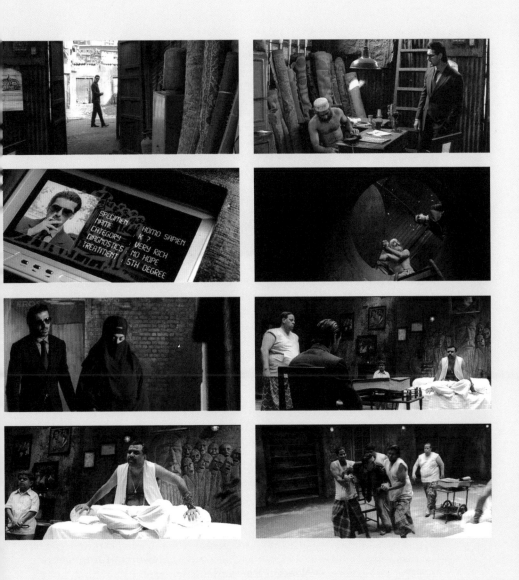

LITTLE ZIZOU (2008)

Cozy Building in the Parsi colony, Gowalia Tank

SOONI TARAPOREVALA, the writer of *Salaam Bombay!* (Mira Nair, 1988) *Such a Long Journey* (Sturla Gunnarsson, 1998) and *The Namesake* (Mira Nair, 2006), made her directorial debut with a delightful English-language comedy set in her Parsi community. Several Parsi families live in *baugs* (gardens) – large and well-ordered residential societies restricted to members of the faith. A great deal of *Little Zizou* plays in these *baugs*, where hearts are broken and mended, heroes clash with villains, and a little boy dreams of meeting the French footballer Zinedine Zidane. Xerxes and his elder brother Artaxerxes are the long-suffering sons of messianic preacher Cyrus II Khodaji, who is dividing the faith with a back-to-roots movement. The film opens with a bang: a group of foreign men and women dressed in army fatigues and sporting submachine guns storm through a *baug* threatening every Parsi they meet. They are members of the 'Parsi Liberation Organization' – a figment of Xerxes's imagination but also a real threat to the liberalism and tolerance represented by Khodaji's opponent, newspaper editor Boman. Taraporevala set the story literally in her backyard: she grew up in Cozy Building in Gowalia Tank near August Kranti Maidan, where the call for the 'Quit India' movement was given by Indian nationalists against the colonial British government on 8 August 1942. Taraporevala also used the homes of family members and friends and cast several of them in key scenes. The result is a beautifully observed comedy that masks a gentle lament for a gradually disappearing way of life: the number of Parsis in the city is dwindling, and many of their distinctive low-rise dwellings are being replaced by high-rise blocks. ❧***Nandini Ramnath***

(Photo © Vikrant Chheda)

Directed by Sooni Taraporevala
Scene description: The PLO (Parsi Liberation Organization) is coming
Timecode for scene: 0:02:03 – 0:03:28

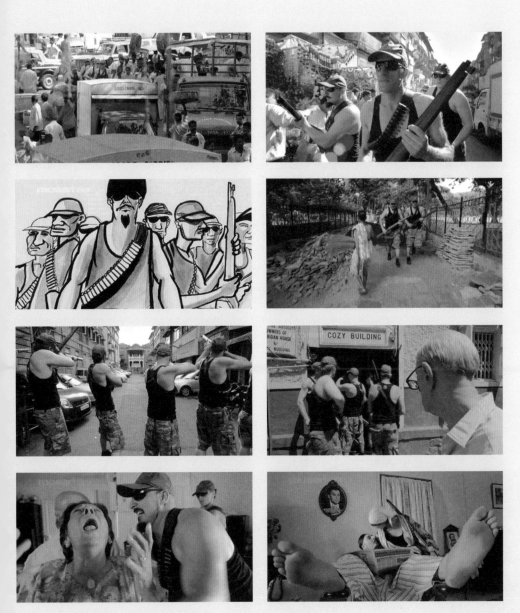

Images © 2008 Jigri Dost Productions, Studio 18

BOLLYWOOD DYNASTIES

Star Power and Lineage in Mumbai's Film Aristocracy

Text by
DEVRATH
SAGAR

IN A NATION OBSESSED with films and their stars, a vast majority of Indians turn to the movies to escape the routine of their daily lives. Living vicariously through characters they watch on-screen, they visit exotic locations most of them will never travel to, romance beautiful people they will probably get to meet only in their dreams, and feel the adrenaline rush of performing death defying stunts without ever coming in harms way. In commercial Indian cinema the draw of big stars by far dwarfs the importance of the film's subject matter, studio or director. In 1982, when Amitabh Bachchan suffered a nearly fatal injury while doing his own stunts for *Coolie* (Manmohan Desai and Prayag Raj, 1983), it made headline news for months and the entire nation prayed for his wellbeing. His most ardent fans subsequently dedicated a temple to him in Kolkata. The plethora of news channels and tabloids enable the public to follow every move of their favourite stars on- and off-screen making them an integral part of the social fabric of the country even beyond the reach of their films. In the Mumbai suburbs of Bandra and

Juhu, where most Bollywood actors live, it's not uncommon to see hundreds of starry-eyed people camp outside their residences hoping to catch just a glimpse of their screen idols. Apartments surrounding megastar Shah Rukh Khan's palatial home Mannat, are sold at a premium owing to the added voyeuristic benefits the occupants enjoy. It's not surprising that legendary scriptwriter and lyricist Javed Akhtar once remarked to Nasreen Munni Kabir that he sees Hindi cinema as 'another state within India'. This 'state', which is one of the most prolific film-making centres in the world and whose 'capital' city is Mumbai, has been for generations 'ruled' to a great extent by a handful of Bollywood dynasties –the Kapoors, Akhtars, Chopras, Bachchans, Khans, Dutts, Sippys, Bhatts, Mukherjees, etc.

In 1928, a young Prithviraj Kapoor took a loan from his aunt, quit law school, and moved from Peshawar (now in Pakistan) to Bombay, to pursue his lifelong ambition of becoming an actor. He fought the odds in this harsh city that has crushed many a dream and forged a successful acting career, first in theatre and eventually in film. His success made the journey through the heavily guarded doors of the Hindi film industry a lot easier for three succeeding generations of his family. Prithviraj's three sons, Raj, Shammi and Shashi, all went on to build landmark careers in their own right. Raj Kapoor founded R. K. Films in 1948, became a superstar in India, and also gained popularity around the world. He in turn launched the acting careers of his three sons, Randhir, Rishi and Rajiv. Rishi Kapoor, whose career spans over 40 years, became India's poster boy with his smash hit debut as a leading man opposite Dimple Kapadia in *Bobby* (Raj Kapoor, 1973). Following in his footsteps, son Ranbir is Bollywood's latest heart-throb along with Aamir Khan's nephew Imran Khan. Not to be left behind, Randhir's

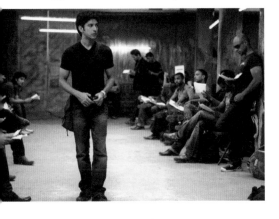

daughters, Karisma and Kareena, are amongst the top Bollywood heroines. The Kapoors could be called the Kennedys of Indian film.

Had an engagement between Karisma Kapoor and Amitabh Bachchan's son, Abhishek, not been called off, the Kapoor dynasty would've been united with the Bachchan family. In 2007 Abhishek married Aishwarya Rai, a top Bollywood heroine, and the best-known Indian actress outside India. Abhishek also enjoyed the benefits of dynastic privilege. His film career got off to a slow start as he endured several flops, but he kept getting new opportunities – a rare thing in an industry that's usually hard on failure – until he tasted major success at the box office with *Dhoom* (Sanjay Gadhvi, 2004).

Although film lineage means a lot in Bollywood, there have been exceptions to the rule. The son of a poet, Amitabh Bachchan, and the current 'King of Bollywood' Shah Rukh Khan, both came to Bombay and made it to the top without the aid of a famous 'filmi' bloodline. Shah Rukh Khan made his debut with the successful television show *Fauji* (R. K. Kapoor, 1988) and got his silver screen break in Hema Malini's *Dil Aashna Hai* (The Heart Knows the Truth, 1992). Yash Chopra's *Darr* (Fear, 1993) began one of the strongest actor-producer partnerships in Indian film history. No film produced by Yash Chopra starring Shah Rukh Khan has ever failed at the box office. Yash Chopra

In 1982, when Amitabh Bachchan suffered a nearly fatal injury while doing his own stunts for *Coolie*, it made headline news for months and the entire nation prayed for his wellbeing.

began his directorial career with elder brother B. R. Chopra in 1959. He then launched his son Aditya, today a prominent director and producer, under his own banner Yash Raj Films. Aditya's first film, *Dilwale Dulhania Le Jayenge* (The Brave Will Take the Bride, 1995), currently enjoys an unbroken run of seventeen years at the Maratha Mandir cinema in Mumbai, surpassing the Salim–Javed penned blockbuster *Sholay* (Ember; Ramesh Sippy, 1975) to become the longest running film in history.

Salim–Javed is the partnership between Salim Khan, superstar Salman Khan's father, and Javed Akhtar. Known for iconic hard-hitting dialogues and responsible for creating Amitabh Bachchan's 'angry young man' image, they became the first writing stars of Indian cinema and ruled the 1970s. Javed Akhtar moved to Bombay in 1964, without a film lineage and with only 27 paise in his pocket. He finally got a break as a scriptwriter for *Yakeen* (Brij, 1969) and went on to build one of the most influential and extensive filmographies in Indian history, having been credited as a writer and lyricist on over a hundred films. His multitalented son Farhan Akhtar burst onto the scene in 2001 with *Dil Chahta Hai* (The Heart Desires), a film that ushered in a new era in mainstream Bollywood by focusing on affluent westernized youngsters. This film attracted urban audiences in the advent of the 'multiplex era', as well as the increasingly important Indian diaspora. Having co-founded one of India's most successful production companies with Ritesh Sidhwani, in 2006 Farhan produced and directed the action blockbuster *Don* (a remake of Chandra Barot's 1978 movie), along with its sequels, and produced and acted in sister Zoya Akhtar's first two ventures, *Luck By Chance* (2009) and the internationally successful *Zindagi Na Milegi Dobara* (You Don't Live Twice, 2011).

'Success is like Alladin's magic lamp. Suddenly the world is a beautiful place and the people good,' Javed Akhtar wrote, 'I see the dust I touch turn to gold' ('Apne Baare Mein' [About Myself] in javedakhtar.com). Although famous last names definitely make it easier to buy a ticket to success in the Bollywood film industry, the likes of Javed Akhtar, Amitabh Bachchan and Shah Rukh Khan inspire countless starry-eyed youngsters to leave their homes in search of that magic lamp that is waiting for them in Mumbai, the city of dreams. ✦

MUMBAI LOCATIONS

SCENES 40-46

SLUMDOG MILLIONAIRE (2008)

LOCATION *Slums near Juhu Airport, Juhu*

ADAPTING VIKAS SWARUP'S novel *Q & A*, Danny Boyle and scriptwriter Simon Beaufoy (*The Full Monty*, Peter Cattaneo, 1997) borrowed from Hindi classics – *Deewaar* (Yash Chopra, 1975), *Black Friday* (Anurag Kashyap, 2004), Ram Gopal Varma's *Satya* (1998) and *Company* (2002), etc. – to make *Slumdog Millionaire*, a heady cocktail of ingredients quintessential to Mumbai and Bollywood – poverty, child abuse, communal violence, gangsters, police brutality, film star fascination, profuse music, even song-and-dance scenes. Unexpectedly, this story of three kids from the slums, brothers Salim and Jamal, and Latika, took eight Oscars, became a worldwide hit and the most successful movie ever shot in India, and was for many spectators their first encounter with cinematic Mumbai. It also upset many Indians who felt it focused on sordid stereotypes of raw poverty and crime. *Slumdog* discovered Dev Patel and beautiful Freida Pinto, and also counted on famous Indian actors in supporting roles – Anil Kapoor, Irrfan Khan, Saurabh Shukla and Mahesh Manjrekar, the director of *Vaastav: The Reality* (1999) and *City of Gold* (2010). A key scene was shot in the slums surrounding the airport of Juhu, an afffluent suburb north of Bandra and also home to film-makers and stars. When Amitabh Bachchan's helicopter lands, everybody runs to get a glimpse of their hero. Salim locks Jamal in a makeshift toilet in revenge for some money he made him lose. Jamal escapes through the toilet hole, and rushes to get Bachchan's prized autograph. This scene defines Salim's dark personality and foreshadows Jamal's stubborn and resourceful determination. At the end Salim is shot in a bathtub full of money, while Jamal endures torture and abuse, but ultimately gets the millions and his dream girl. ➻ ***Helio San Miguel***

(Photos © Devrath Sagar)

Directed by Danny Boyle and Loveleen Tandan
Scene description: Jamal beats all odds to get an autograph of Amitabh Bachchan
Timecode for scene: 0:10:08 – 0:12:50

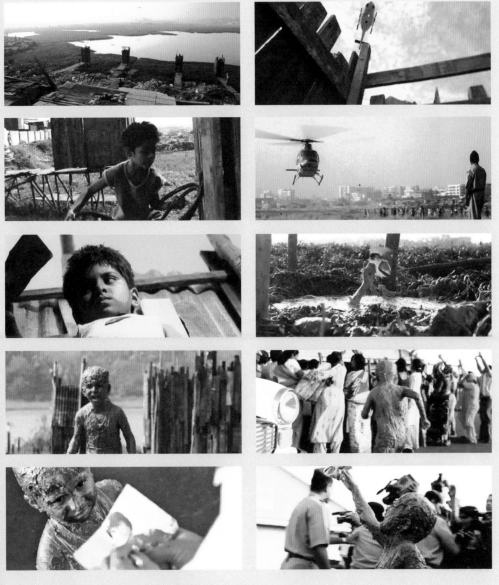

KAMINEY (2009)

KAMINEY (THE SCOUNDRELS) was produced by UTV founder Ronnie Screwvala and directed by multitalented Vishal Bhardwaj. Bhardwaj is a musician, playback singer, and composer of over thirty films. He is also a writer, director and producer. Among his films are *Maqbool* (2003), *Macbeth* adapted to the Mumbai underworld; *The Blue Umbrella* (2005), an adaptation of Ruskin Bond's novel; and *Omkara* (2006), where he set *Othello* in Uttar Pradesh. In *Kaminey*, Charlie (Shahid Kapoor) is an ambitious young gangster who has grand visions of himself. He also has it very clear in his mind that there are only two ways to get rich, 'the short cut and the even shorter cut'. His gang's short cut is fixing derbies at Mumbai's Mahalaxmi Racecourse located in the homonymous neighbourhood. Opened since 1883, its design was inspired by Melbourne's Caulfield. The season runs between November and April and it also hosts riding classes. When there are no races the tracks are open to the public to jog and do yoga. It also serves as a helipad. In *Kaminey* a jockey takes his own shorter cut and double-crosses Charlie winning a race he had agreed on to lose. This creates havoc for Charlie, who loses a lot of money, and this is the catalyst for a thriller that involves his twin brother, corrupt police officials, Maharashtrian nationalist politicians, African gangsters, and a guitar full of cocaine valued in millions that Charlie finds when he inadvertently steals a car that belongs to the police's narcotics division. ⇥ ***Helio San Miguel***

(Photo © Sunhil Sippy)

Directed by Vishal Bhardwaj
Scene description: A jockey double-crosses Charlie, triggering an unexpected chain of events
Timecode for scene: 0:03:14 – 0:06:16

LUCK BY CHANCE (2009)

Bandra-Worli Sea Link, from the Bandra side

IN THIS SCENE FROM *Luck by Chance*, a Bollywood film about Bollywood, dusk falls over the under-construction Bandra-Worli Sea Link. The iconic 5.6 km (3.5 mile) cable-stayed bridge (the longest over water in India) was built over the Mahim Bay and connects Mumbai's western suburb of Bandra with mid-town Worli. Fraught with five years of political delays and litigation problems, the Sea Link finally opened to traffic in June 2009. Writer and director, Zoya Akhtar, draws parallels between this bridge and the journeys of her film's lead characters, Sona (Konkona Sen Sharma) and Vikram (Farhan Akhtar). They are both on obstacle-ridden paths in pursuit of stardom in the Mumbai film industry, where lineage often counts for more than talent. Sona is sleeping with a married B-film producer in the hope that he will cast her in a mainstream film, whereas Vikram, who believes 'success and failure are only choices we make', sweet-talks anyone connected to the industry, whether it's an assistant director or a starlet of yesteryear. As Vikram's luck and knack for pressing the right buttons would have it, he soon lands the leading part in the first mainstream film he auditions for. Sona on the other hand isn't as lucky and is deceived by the producer and later, Vikram. Hope, aspiration, hard work, connections, betrayal, politics and luck are some of the elements needed to make the heady cocktail that is Bollywood. Filled with these ingredients, *Luck By Chance* gives the audience a behind the camera view of the Mumbai film industry. **Devrath Sagar**

(Photos © Devrath Sagar and Ravi Bohra)

Directed by Zoya Akhtar

Scene description: Vikram and Sona sit on a wall besides the Bandra-Worli Sea Link

Timecode for scene: 0:34:45 – 0:35:50

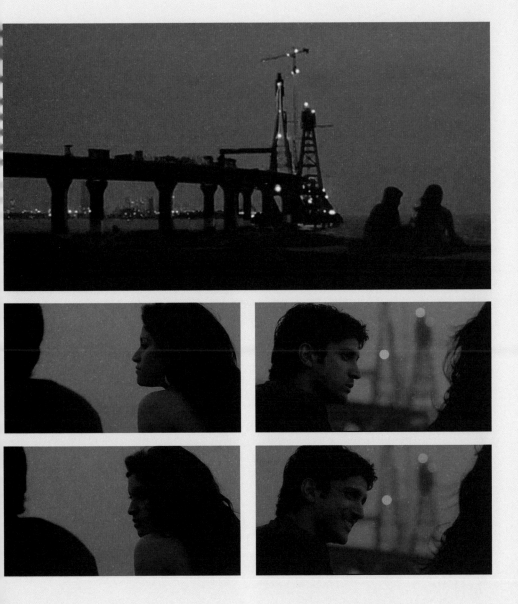

SANKAT CITY (2009)

LOCATION *Gorai dumping ground, Gorai*

PANKAJ ADVANI'S comic caper is as maniacal as the gigapolis that inspired it. Advani flips the ultimate Mumbai dream – to have lots of money right here and right now – on its head. *Sankat City* (Problem City) follows an assorted bunch of cons and small-time crooks as they chase a suitcase containing a few million rupees all over Mumbai. They are such far-out characters that they probably don't deserve the dosh. Nor does 'the city that doesn't sleep and doesn't let you sleep'. Shady dives, run-down garages, garish brothels, dilapidated apartments – Advani doesn't spare us reminders of just how unpleasant bits of Mumbai can be. Thus, when the leading pair tracks the aforementioned suitcase to a sprawling garbage dump that is governed by a man who looks as though he has stepped out of the album cover of *Sgt. Pepper's Lonely Hearts Club Band* (1967), you are not one bit surprised. It's par for the course. In the short but memorable sequence, filmed with tremendous gumption by the cast and crew at the Gorai dumping ground (since shut down to make way for a proposed park), Advani provides a striking visual metaphor for Mumbai's related tendencies towards excess and waste. The area of Gorai, located on the northwest edge of Mumbai, is also the home to beaches and other attractions like the Vipassana Pagoda. ➛*Nandini Ramnath*

(Photo © Devrath Sagar)

Directed by Pankaj Advani
Scene description: A suitcase of money ends up at a garbage dump
Timecode for scene: 1:27:42 – 1:30:42

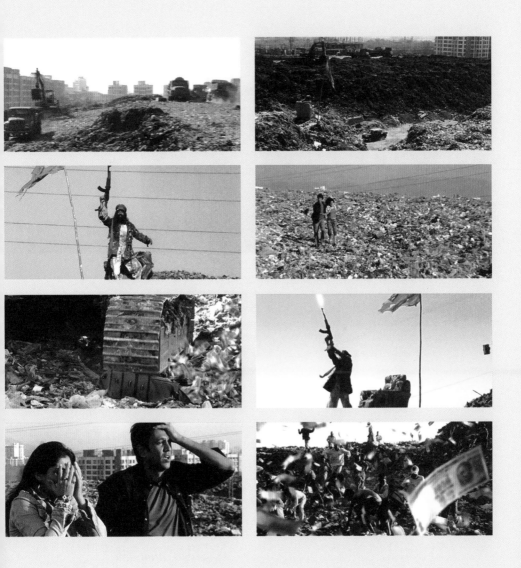

CITY OF GOLD – MUMBAI 1982: EK ANKAHEE KAHANI (2010)

LOCATION *Tata Mills and India United Mills along Dr Ambedkar Road, Parel*

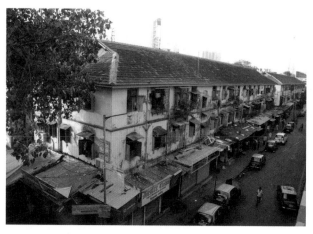

THE GREAT BOMBAY Textile Strike of 1982 was one of the most traumatic and transformative events in the recent history of the city and one of the longest strikes ever. Organized by powerful trade union leader and politician Dutta Samant (who was gunned down fifteen years later) it lasted over a year, and affected over fifty mills and 250,000 workers. In the end the workers didn't succeed and it precipitated the dismantling of the mills. The result was the still on-going transformation of Girangaon ('mill village' in Marathi) in central Mumbai into a commercial and residential area at the expense of its social fabric. Most mills and the *chawls* where the workers lived were demolished and replaced by skyscrapers and swanky malls. Conservationists fight to preserve the few remaining ones as part of Mumbai's history. *City of Gold* portrays this conflict through the flashback of a writer who remembers his family story. The film is quite melodramatic, some characters are somewhat one-dimensional, and it focuses heavily on the descent into crime and violence, but it offers a painstaking recreation of this important event. Significant parts were shot in studios, but the scene that ignites the struggle – the posting of the closing notice and the workers' reaction calling the union leaders and tearing down the notice – was shot on location. Two important classics *Katha* (Sai Paranjape, 1983) and *Mohan Joshi Hazir Ho!* (Summons for Mohan Joshi; Saeed Akhtar Mirza, 1984) have also depicted life in the *chawls*. **➥Helio San Miguel**

(Photos © Vikrant Chheda)

Directed by Mahesh Manjrekar
Scene description: The owners post a note announcing the closing of a textile mill
Timecode for scene: 0:19:28 – 0:21:15

ONCE UPON A TIME IN MUMBAAI (2010)

Eros Cinema, Cambata Building, 42 M. Karve Road, Churchgate

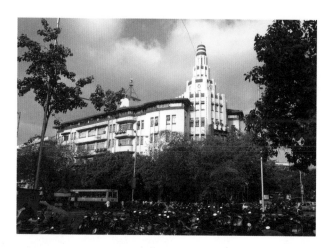

ONCE UPON A TIME IN MUMBAAI is a retro film that develops a panoramic view of Mumbai. This is the tale of the rise of Mumbai's underworld inspired by the real life stories of gangsters Haji Mastan and Dawood Ibrahim. The film positions the Robin Hood-style gangsterism of Haji Mastan against the current form associated with terrorism. Sultan Mirza (Ajay Devgn) is a gangster with a good heart while Shoaib Khan (Emraan Hashmi) is unscrupulous. The film is set within the aesthetic universe of 1970s cinematic style and costume, presented via Sultan's lover, Rehana (Kangana Ranaut), a Bollywood star. During a premiere of one of her films, the single-screen theatre experience that was distinctive of the pre-multiplex era is established. The sequence was shot in the Eros Cinema, one of the few remaining grand art deco theatres in Mumbai (along with Metro, Regal, Liberty, etc.). Designed by Sohrabji Bhedwar, it opened in 1938 showcasing its dramatic form in its facade and interior. In the premiere sequence, we first see the theatre hall with its rexine-upholstered seats. When Sultan enters, Rehana gets up dramatically to join him. As they walk out into the white and black marble foyer, the camera reveals the elaborate texture of the theatre's art deco ceiling with its little traces of gold. The upper floor connected by a marble staircase with chromium handrails is used for Rehana's dramatic descent in another sequence of the film. The use of Eros in *Once Upon a Time in Mumbaai* provides spectators with a nostalgic experience of cinema watching associated with Mumbai's pre-multiplex past. **→Ranjani Mazumdar**

(Photo © Vikrant Chheda)

Directed by Milan Luthria
Scene description: Sultan attends Rehana's film premiere
Timecode for scene: 0:30:20 – 0:31:37

MUMBAI DIARIES/DHOBI GHAT (2010)

LOCATION *21 Keshavji Naik Road, Bhaat Bazaar*

SHAI (MUSICIAN MONICA DOGRA), an investment banker living in New York, is back in Mumbai on a sabbatical. One day she meets painter Arun (megastar Aamir Khan) and ends up spending the night with him. But Arun is reluctant to start a new relationship. He is coming out of a divorce and is looking for a new place. At the same time Shai, in the rigid Indian class structure, develops an unlikely friendship with Munna (Prateik), a *dhobi* (laundry worker), who dreams of being an actor, and walks her around the city to take photographs – her passion. Munna gives her Arun's new address in Bhaat Bazaar, a crowded and colourful area near Mohamed Ali Road and the imposing Minara mosque. There, Arun finds three tapes left over by the previous tenant. In them Yasmin, a young wife, tapes tourist sites for her brother (Marine Drive, Gateway of India, Elephanta Caves, etc.), sprinkled with her candid and sometimes poetic impressions. But soon they turn more personal – and darker. A short scene encapsulates the power of this low budget but complex and nuanced film. Arun, increasingly captivated by Yasmin's videos, starts to sketch her. Shai, still infatuated with him, secretly takes pictures of him. All characters express themselves through different layers of visual exploration that ultimately unveil something very deep about them. And then director Kiran Rao, closer to Rohmer and Wong Kar-wai than to India's *parallel* tradition, turns her camera on them to give us with *Mumbai Diaries* a profound and poetic vision of Mumbai that transcends the stories of its characters to reveal the soul of a city that, despite its many failings, is utterly alluring. **Helio San Miguel**

(Photo © Vikrant Chheda)

Directed by Kiran Rao
Scene description: Shai stalks Arun while he watches Yasmin's videos
Timecode for scene: 0:43:18 – 0:45:12

GO FURTHER

Recommended reading, useful websites and film availability

BOOKS

Behind the Beautiful Forevers: Life, Death, and Hope in a Mumbai Undercity
by Katherine Boo
(Random House, 2012)

**Bollywood:
A Guidebook to Popular Hindi Cinema**
by Tejaswini Ganti
(Routledge, 2004; repr. 2013)

Bollywood: The Indian Cinema Story
by Nasreen Munni Kabir
(Channel 4 Books, 2002)

Bombay
by Lalitha Gopalan
(British Film Institute Modern Classics, 2008)

Bombay Cinema: An Archive of the City
by Ranjani Mazumdar
(University of Minnesota Press, 2007)

Bombay, Meri Jaan: Writings on Mumbai
edited by Jerry Pinto and Naresh Fernandes
(Penguin Books, 2003)

Bombay: Mosaic of a Modern Culture
edited by Sujata Patel and Alice Thorner
(Oxford University Press, 1995)

Bombay Talkies: 2004-2005
by Mayank Shekhar
(Kumarian Press, Inc., 2006)

Bombay: The Cities Within
by Sharada Dwivedi and Rahul Mehrotra
(India Book House, 1995; repr. by Eminence Designs, 2001)

Bombay Then and Mumbai Now
by Naresh Fernandes
(Lustre Press, 2009)

Bombay to Mumbai: Changing Perspectives
edited by Pauline Rohatgi, Pheroza Godrej and Rahul Mehrotra
(Marg Publications, 1997)

Breathless in Bombay
by Murzban F. Shroff
(St. Martin's Griffin, 2008)

City Flicks: Indian Cinema and the Urban Experience
edited by Preben Kaarsholm
(University of Chicago Press, 2006)

Encyclopaedia of Indian Cinema
by Ashish Rajadhyaksha and Paul Willeman
(Routledge, 1999)

Indian Cinema in the Time of Celluloid
by Ashish Rayadhyksha
(Indiana University Press, 2009)

Love and Longing in Bombay
by Vikram Chandra
(Back Bay Books, 1998)

Maximum City: Bombay Lost and Found
by Suketu Mehta
(Knopf, 2004)

Midnight's Children
by Salman Rushdie
(Random House, 1981; repr. 2006)

Mumbai Diary
by Sunhil Sippy
(Pictor Publishing, 2011)

Mumbai Fables
by Gyan Prakash
(Princeton University Press, 2011)

Producing Bollywood: Inside the Contemporary Hindi Film Industry
by Tejaswini Ganti
(Duke University Press Books, 2012)

Sacred Games
by Vikram Chandra
(Harper Perennial, 2007)

Shantaram
by Gregory David Roberts
(St. Martin's Griffin, 2005)

So Many Cinemas:
The Motion Picture in India
by B. D. Garga
(Eminence Designs, 1996)

The Moor's Last Sigh
by Salman Rushdie
(Pantheon, 1996)

ONLINE

Bollywood Hungama
one of the leading websites providing
news, reviews, and box office reports about
Bollywood.
www.bollywoodhungama.com

Channel 4 of Britain
for years has offered an Indian film season
curated by author, documentary film-maker,
inspirational figure, and indefatigable
promoter of Indian cinema Nasreen Munni
Kabir.
www.channel4.com/programmes/india-season

DearCinema
website focusing on film festivals and
independent and arthouse films and shorts,
from India and the world.
www.dearcinema.com

Eros International
important production and distribution
company based in Mumbai. It produces movies
and distributes them for theatrical releases,
television, cable, digital platforms and DVDs.
dvdstore.erosentertainment.com

Films Division of India
office of India's Ministry of Information
and Broadcasting, in charge of production
and distribution of documentaries, news
programs and shorts.
filmsdivision.org

Moserbaer
distributes a large selection of DVDs,
mostly of modern titles.
www.moserbaerhomevideo.com

Mumbai Film Festival
international film festival organized by
the Mumbai Academy of the Moving Image.
www.mumbaifilmfest.com

Mumbai International Film Festival
International film festival organized by
the Films Division of India, focusing on
documentaries, shorts and animation films.
www.miffindia.in

National Film Development Corporation
government agency for the production and
promotion of Indian cinema. It restores films
and releases DVDs under the Cinemas of
India collection.
www.nfdcindia.com

Netflix
Netflix has a surprisingly large selection
of Indian films.
movies.netflix.com

Shemaroo
Shemaroo has a broad selection of DVDs,
including both modern and classic titles.
www.shemaroo.com

CONTRIBUTORS

Editor, contributing writer and photographer biographies

EDITOR

HELIO SAN MIGUEL holds a Ph.D. in Philosophy and an MFA in Film and TV Direction and Production from New York University. He teaches film at The New School in New York City, and has written and lectured extensively about cinema. His areas of specialization are film theory and aesthetics, and western, Indian and Latin American cinemas. He has contributed to *World Film Locations: Madrid* (Intellect, 2012), *The Cinema of Latin America* (Wallflower Press, 2002) and *Tierra en Trance* (Alianza Editorial, 1998). He is also the co-editor (with Alberto Elena) of a monographic issue for the *Secuencias* journal on the changes in Bollywood in the last two decades. Helio is also the writer and director of *Blindness* (2007), a 32-minute fiction film selected in over thirty festivals, including 'New Filmmakers New York' and the 'European Film Festival'. His interest in India started while in college and became heightened when he met his now wife, Tina Malaney, a born and bred Mumbaikar.

CONTRIBUTING WRITERS

ALBERTO ELENA is currently a professor of Media Studies at the Carlos III University of Madrid. Member of the editorial boards of *New Cinemas*, *Secuencias* and *Archivos de la Filmoteca*, he has organized numerous film retrospectives and has been on the jury of a variety of international festivals. His publications include *El cine del Tercer Mundo: Diccionario de realizadores* (Editorial Turfán, 1993), *Satyajit Ray* (Cátedra, 1998), *Los cines periféricos: Africa, Oriente Medio, India* (Editorial Paidós Ibérica, 1999), *The Cinema of Latin America* (Wallflower, 2003; with Marina Díaz López), *The Cinema of Abbas Kiarostami* (Saqi Books, 2005) and *La llamada de África: Estudios sobre el cine colonial español* (Bellaterra, 2010), as well as various contributions to specialized journals.

LALITHA GOPALAN is an associate professor in the Department of Radio-Television-Film at the University of Texas at Austin, and affiliate faculty in the Department of Asian Studies and South Asia Institute. She is the author of *Cinema of Interruptions: Action Genres in Contemporary Indian Cinema* (BFI Publishing, 2002) and *Bombay* (BFI Modern Classics, 2005), and editor of *The Cinema of India* (Wallflower Press, 2010). Her current book project explores various experimental film and video practices in India.

RANJANI MAZUMDAR teaches at the School of Arts and Aesthetics, Jawaharlal Nehru University, New Delhi. Her publications focus on technological culture, globalization, film posters and the cinematic city. She is the author of *Bombay Cinema: An Archive of the City* published by the University of Minnesota Press (2007) and co-author of the forthcoming *The Indian Film Industry* (BFI/Palgrave, 2013). Mazumdar has also worked as a documentary film-maker and is a founding member of Mediastorm, India's first women's film collective. Her documentaries include *Delhi Diary 2001* (on violence, memory and the city); *The Power of the Image* (co-directed; a television series on Bombay cinema); and *Prisoner of Gender*. Her current research focuses on the intersection of tourism, travel and cinema in the 1960s.

NANDINI RAMNATH was born in Mumbai and has lived there for most of her life. She studied sociology and psychology at St Xavier's College and did a diploma in media studies from Sophia Polytechnic. She is a film reporter with the newspaper *Mint*. She has previously worked with *Time Out Mumbai*, *NDTV 24x7* and *The Indian Express*.

DEVRATH SAGAR is a writer, photographer and film-maker based in Mumbai. After working for six years as a freelance assistant director on commercials and feature films for various production houses including The Walt Disney Company, Excel Entertainment, Highlight Films and Future East, he went to New York to study film at The New School and started his writing and directing career with his short film *In Theory*.

MAYANK SHEKHAR, taking up journalism after graduating in economics from Delhi's St Stephen's College, has been a popular writer and film critic for over a decade, first with *Mid Day*; then with *Mumbai Mirror*, the *Times of India*'s city daily that he was in the founding team of; and then with *Hindustan Times*, where he served as the national cultural editor. Picking up a number of journalism awards along the way, in 2007, Mayank became the first recipient of the Ramnath Goenka Award, India's equivalent of the Pulitzer Prize, for film and television journalism. His first book *Bombay Talkies* was published in 2006 by Kumarian Press. Besides his engagement with print, Mayank has anchored shows for several national television networks, and served on the jury of many international film festivals.

PHOTOGRAPHERS

RAVI BOHRA is a photographer based in Mumbai. His photographs of Mumbai and its inhabitants have featured in the *Times of India*, *Elle* magazine, and in the acclaimed film *Dhobi Ghat/Mumbai Diaries* (Kiran Rao, 2010).

VIKRANT CHHEDA is a freelance photographer and entrepreneur living in Mumbai. In 2011 he started an adventure travel company called *White Collar Hippie*

(*whitecollarhippie.com*) that specializes in journeys off the beaten path.

RAJ HATE is a freelance line producer for films and commercials based in Mumbai. His love for photography began while taking recce stills for numerous projects he has worked on.

SUNHIL SIPPY is a London bred, Georgetown educated Indian who now lives in Mumbai as a professional filmmaker and avid photographer. Although his professional work is in advertising, he has been documenting Mumbai through feature length fiction (*Snip!*, 2000) and through his countless photographs. In 2011 Sunhil Sippy published his first book, a diary based on his black and white images of the city (*Mumbai Diary*, Pictor Publishing), and he is currently working towards an exhibition of his work, tentatively titled "Bombay in CinemaScope."

FILMOGRAPHY

All films mentioned or featured in this book

NOTES ON FILM TITLES:

Most Indian movies, especially Hindi ones, are known and officially distributed nationally and internationally by the titles in their original languages transliterated into the Latin alphabet. This is how we list them in the book, offering a translation of their meaning in parentheses. When they are listed in English it is because that was their official title, or because they had a wide international distribution with the English title. Due to the fact that letters in the Devanagari alphabet, used in Hindi and other languages, don't correspond exactly with the Latin ones, sometimes there are different transliterations (especially regarding long vowels). As a convention we have followed the transliteration that appears on the International Movie Database (IMDb), except for those few cases in which the movie itself prominently displays another spelling.

27 Down (1974)	31,36
Aag (1948)	11,12
Aakhri Khat (1966)	11,26
Aakrosh (1980)	48
Alam Ara (1931)	9
Albert Pinto Ko Gussa Kyon Ata Hai (1980)	48
Allah Ke Banday (2010)	49
Amar Akbar Anthony (1977)	31,42
Anubhav (1971)	49
Ardh Satya (1983)	51,58
Awara (1951)	11,14,68
Baazi (1956)	68
Bandit Queen (1994)	74
Barah Aana (2009)	49
Baton Baton Mein (1979)	49
Being Cyrus (2006)	49
Bhavni Bhavai (1980)	48
Bhindi Baazaar Inc. (2011)	72
Bhoot (2003)	89
Black Friday (2004)	49,69,89,91,96,102,110
Blue Umbrella, The (2005)	112
Bobby (1973)	106
Bombay (1995)	71,80,88,89
Bombay, Our City/Hamara Shahar (1985)	76
Bombay Talkie (1970)	31,32
Bomgay (1996)	7
Chakra (1981)	49,76
Chandni Bar (2001)	91,92
Chhoti Si Baat (1975)	48
C.I.D (1956)	29,68
City of Gold – Mumbai 1982: Ek Ankahee Kahani (2010)	109,110,118
Company (2002)	69,110
Coolie (1983)	106
Darr (1993)	107
Deewaar (1975)	31,40,110
Dharavi (1992)	49,71,76
Dhoom (2004)	107
Dil Aashna Hai (1992)	107
Dil Chahta Hai (2001)	107
Dilwale Dulhania Le Jayenge (1995)	107
Dombivli Fast (2005)	91,98
Don (1978)	31,46

Don (2006)	107
Duvidha (1975)	74
Ek Tho Chance (2011)	72
Elizabeth (1998)	74
Fauji (1988)	107
Five Obstructions, The (2003)	91,94
Fiza (2000)	71,86
Full Monty, The (1997)	110
Gandhi (1982)	51,56
Gharaonda (1977)	31,44
Godfather: Part II, The (1974)	82
Guddi (1971)	31,34
Gumrah (1963)	11,24
Haqeeqat (1964)	26
Hey Ram (2000)	88
Hiroshima Mon Amour (1959)	89
I am (2010)	7
India Cabaret (1985)	64
Is Raat Ki Subah Nahin (1996)	68
Jaane Bhi Do Yaaro (1983)	49,51,60
Jamai Shashthi (1931)	9
John & Jane (2005)	7,91,100
Johnny Gaddar (2007)	69
Kaagaz Ke Phool (1959)	11,22
Kagemusha (1980)	46
Kalyug (1981)	51,54
Kaminey (2009)	109,112
Kanoon (1960)	24
Katha (1983)	49,118
Kismet (1943)	22
Last Irani Chai, The (2011)	58
Little Zizou (2008)	49,91,104
Luck By Chance (2009)	107,109,114
Made in India (2010)	7
Mahabharat (1988-1990)	24
Mahal (1949)	68
Mammo (1994)	71,78
Manthan (1976)	48
Manzil (1979)	51,52
Maqbool (2003)	69,112
Mashaal (1984)	51,62
Mere Mehboob (1963)	89
Mirch Masala (1987)	48